101 TEXTURES
IN COLORED PENCIL

PRACTICAL STEP-BY-STEP DRAWING TECHNIQUES
FOR RENDERING A VARIETY OF SURFACES & TEXTURES

DENISE J. HOWARD

Brimming with creative inspiration, how-to projects, and useful information to enrich your everyday life, Quarto Knows is a favorite destination for those pursuing their interests and passions. Visit our site and dig deeper with our books into your area of interest: Quarto Creates, Quarto Cooks, Quarto Homes, Quarto Lives, Quarto Drives, Quarto Explores, Quarto Gifts, or Quarto Kids.

First published in 2017 by Walter Foster Publishing,
an imprint of The Quarto Group.
26391 Crown Valley Parkway, Suite 220, Mission Viejo, CA 92691, USA.
T (949) 380-7510 **F** (949) 380-7575 **www.QuartoKnows.com**

ISBN: 978-1-63322-340-0

Acquiring & Project Editor: Stephanie Carbajal
Page Layout: Elliot Kreloff

Printed in China
10 9 8 7 6

Table of Contents

GETTING STARTED

How to Use This Book

This book includes step-by-step instructions for achieving a wide range of textures with colored pencil.

1. GATHER the tools and materials you need to start drawing. (See pages 6–9.)

2. LEARN the drawing techniques on pages 10–15. Acquainting yourself with the vocabulary and methods for working in colored pencil will help you quickly and easily understand the instructions for replicating each texture.

3. LOCATE your desired texture in the Table of Contents on page 3. The textures are organized in the following six categories:

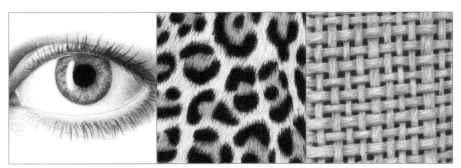

People **Animals & Insects** **Fabrics & Textiles**

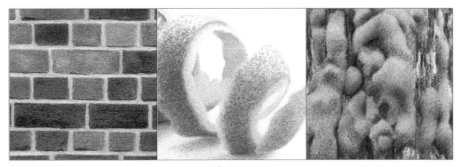

Glass, Stone, Ceramics, Wood & Metal **Food & Beverage** **Nature**

4. FOLLOW the step-by-step process outlined to draw your texture.

5. PRACTICE the texture as it appears in the book; then integrate the textures into your own drawings.

Tools & Materials

Paper

The *tooth*, or texture, of a paper grabs and holds onto pigment. The toothier the paper, the rougher it is and the more pigment it will hold, but that also makes it more difficult to achieve a smooth, blended look with no speckles of paper peeking through. Very smooth paper makes it easier to create fine, smooth details, but it will not accept as much pigment, making it more difficult to achieve rich, complex color. Examples of toothy paper are cold-pressed watercolor paper and papers made for use with pastels. Example of very smooth paper are smooth and plate bristol. In between are papers such as hot-pressed watercolor paper, vellum bristol, and printmaking paper, such as Stonehenge.

Choose good-quality, acid-free paper that has the right characteristics for the textures you plan to depict, and practice on it first to familiarize yourself before launching into a full project. For all my work, I prefer acid-free, 100-percent cotton rag, archival paper. I used white Stonehenge paper for all the examples in this book because of its consistent, fine tooth, durability, and availability in many art supply stores—in both pads and large single sheets.

EXTRA PAPER Always keep a disposable sheet of paper under your drawing hand as you work to protect the drawing from the oils of your hand and prevent smudging. Glassine is excellent for this—it looks like wax paper but is more slippery. Plain printer paper will also do.

Pencils

GRAPHITE For planning basic outlines, a graphite pencil of grade HB or H works well. It is a little harder than a standard 2B, so it deposits less graphite on the paper. Use it lightly so that it doesn't dent the paper.

COLORED Whatever the brand, colored pencils fall into two main types: wax-based and oil-based. This refers to the composition of the binder that holds the pigment together to form the pencil core. Wax-based pencils are softer and creamier, while oil-based pencils are harder and drier. They can be used together, and neither is better than the other—they're just different.

Depending on the brand, full sets range from 72 colors to 150 colors. Although purchasing the largest possible set of a brand is always tempting, it's not necessary to make beautiful drawings. A smaller set of 24 or 36 colors can produce a broad spectrum once you learn a little color theory and how to layer them. Many stores also sell individual "open stock" pencils, so you can add the colors you need to your collection as you need them. Avoid cheap "student-grade" or children's pencils. They don't blend well and the colors will change or fade over time.

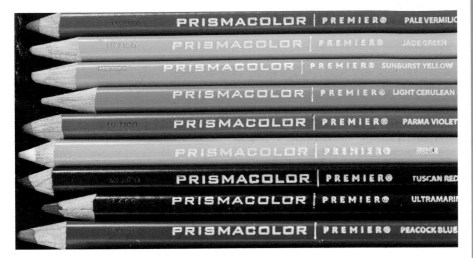

I used Prismacolor® Premier® colored pencils for all the examples in this book. These wax-based pencils are readily available from any store that carries art supplies and are reasonably priced. You may prefer a different brand. Experiment to find the pencils that suit you best.

Erasers

KNEADED RUBBER Applying a light color over a graphite outline is a recipe for disappoint-ment—at best, the graphite will become more noticeable; at worst, it will smear. To avoid this, a kneaded rubber eraser is a must-have. Throughout the book, when preparing to draw with light colors, you'll see that I suggest dabbing away as much of the graphite outline as you can and still see it. I recommend doing this ahead of not only light colors but any colors. Never scrub with the eraser—scrubbing damages the surface of the paper.

POSTER PUTTY Colored pencil is not easy to erase, and almost never erases completely. Lifting it off paper reasonably well requires something with more tackiness than kneaded rubber: poster putty. This is the same stuff that students use to hang posters on walls! Depending on the brand, it might be white, blue, or green; the color doesn't matter. Like kneaded rubber, it can be pinched and rolled into a fine point or a line. It works best by gently dabbing at the paper surface. Again, never scrub the paper. It's a must-have for corrections, lifting the inevitable little blobs of pig-ment, and cleaning up edges.

OTHER Some artists find great value in electric erasers, or those that come in a holder that clicks like a mechanical pencil. Either of these can be sharpened to a fine point to make crisp edges.

> ### ARTIST TIP
> When working with wax-based pencils, occasional blobs of pigment inevitably appear.
> Even tiny ones can be quite noticeable. When this happens, don't try to keep drawing over
> them—they will only grow by grabbing more pigment. Instead, pinch your poster putty
> down to a tiny point and gently dab them off right away.

Blenders & Solvents

Whether you choose to use blenders and solvents is a personal choice—some artists prefer their work to look like a drawing, even if they depict a very smooth texture, while others prefer their work to look like a painting, even if they depict a very rough texture. In this book, I often use a colorless blender or solvent to demonstrate what a big difference it can make.

COLORLESS BLENDER A colorless blender is a colored pencil with no color—just binder and waxes or oils. Most colored pencil manufacturers make a colorless blender designed to work well with their pencils, sold separately from their sets. I used a colorless blender for many examples in this book.

SOLVENT The binder that holds colored pencil pigment together is easily dissolved with a little solvent, either alcohol or odorless mineral spirits. Both evaporate quickly, leaving no residue. Solvent does not turn the pencil into a watercolor effect of liquid color that you can pull around with a brush; it drops the pigment in place into the tooth of the paper, eliminating speckles of paper peeking through and producing a more even, intense color. This is useful when you want to smoothly blend two to three layers of pigment but preserve the tooth of the paper so you can continue with more layers on top.

Whenever I mention using odorless mineral spirits, you can also substitute alcohol. I used odorless mineral spirits for several textures in this book: Smooth Skin (#1), Rusted Steel (#51), and Still Lake (#93).

Sharpener

There are hand-held, hand-cranked, and electric sharpeners. There is no "best" sharpener, but I do recommend getting an electric one to save time, since you will be sharpening often. When working with colored pencils, it's crucial to get a very sharp point, and sometimes you may need to sharpen every 90 seconds! For an electric or hand-cranked sharpener, choose one with a helical mechanism, as it will last longer and be gentler on the pencils. Occasionally sharpen a graphite pencil in the sharpener to clean the blades of waxy buildup.

ARTIST TIP
Rotate your pencil a quarter turn frequently during use between sharpening, so that the sharpest part of the point is always on the paper. Sharpen often!

Stylus

A stylus is a pen-shaped instrument with a tiny steel ball tip, used for impressing lines into paper without damaging it. An empty extra-fine ballpoint pen will do in a pinch, but manufactured styluses are available with much smaller tips. Do not use a sewing pin or a wire, such as a straightened paper clip—the sharp end will cut your paper.

Swatch Chart

The biggest time-saver for working with colored pencil is a swatch chart. For every set of pencils you own, arrange them in color sequence. Then make swatches of color in that sequence on a large piece of paper, and label each swatch with its name. Keep your pencils arranged in that order, and keep your swatch chart next to you while you work. Whenever you need a certain color, you need only to find it on your swatch chart and go right to it in your set, without wasting time making test scribbles to see what color comes close.

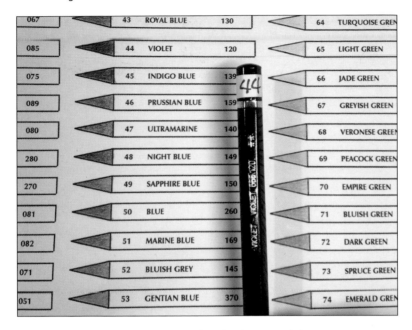

067			43	ROYAL BLUE	130		64	TURQUOISE GREEN
085			44	VIOLET	120		65	LIGHT GREEN
075			45	INDIGO BLUE	139		66	JADE GREEN
089			46	PRUSSIAN BLUE	159		67	GREYISH GREEN
080			47	ULTRAMARINE	140		68	VERONESE GREEN
280			48	NIGHT BLUE	149		69	PEACOCK GREEN
270			49	SAPPHIRE BLUE	150		70	EMPIRE GREEN
081			50	BLUE	260		71	BLUISH GREEN
082			51	MARINE BLUE	169		72	DARK GREEN
071			52	BLUISH GREY	145		73	SPRUCE GREEN
051			53	GENTIAN BLUE	370		74	EMERALD GREEN

I have several swatch charts available to download on my website: www.denisejhowardart.com/downloads-media.html.

Fixatives

Fixative is a liquid spray that creates a barrier. There are two main types: workable fixative and final fixative. Workable fixative allows you to continue drawing more layers on top without affecting or blending into the layers underneath. Final fixative completely seals the surface of the drawing to protect it from smudging, and is only used upon completion.

For wax-based pencils, final fixative is especially important to prevent wax bloom. Over time, the wax from the binder can migrate to the surface of a drawing, causing a blotchy, cloudy look, known as wax bloom. Bloom is more likely with heavy layers of pigment and more noticeable on dark colors. It's easy to fix by gently wiping the paper's surface with a very soft cloth or cotton swab, but it's better to prevent it by using final fixative. Follow the directions on the can.

Drafting Brush

Crumbs of pigment inevitably appear, along with dust particles and fibers. Resist the urge to sweep them away with your hand, which could embed them into the paper or smudge your drawing. Instead, use a drafting brush; this is exactly its purpose.

Techniques & Color Mixing

As an art medium, colored pencil is similar to watercolor: you work from light to dark, reserving bare paper for the lightest highlights; once an area is dark, it's impossible to make it fully light again. This is important to keep in mind if you're familiar with media that work the opposite, such as pastels, where you work from dark to light and add the highlights last. Unlike paint, you cannot wipe out or paint over errors and start again. But since colored pencil drawings develop slowly, errors do too, so you have time to notice and correct them before they become irreparable.

Following are some of the basic stroke techniques, effects, and blending methods used to create the drawings in this book. Practice them several times on scrap paper before using them in a project, since colored pencil is not easy to erase!

Holding the Pencil

The position of the pencil relative to the surface of the paper is important for colored pencil drawing, because it affects how evenly and thoroughly the pigment is laid down.

FLAT Holding the pencil so that the side of the point is flat against the paper and stroking with it deposits pigment unevenly and creates a very coarse look. This is useful for drawing textures like rough bark, sand, and rock.

NORMAL Holding the pencil as if you are writing with it, but at a slightly more vertical angle, is the normal position for colored pencil. This ensures that a good amount of pigment gets into the tooth of the paper with each stroke.

VERTICAL Holding the pencil perpendicular to the paper and using a circular/scumbling stroke ensures that the pigment gets fully down into and around the tooth of the paper to create very smooth, complete coverage that reveals no stroke direction.

Sharpness & Pressure

Throughout the tutorials in this book, each step describes the sharpness of the pencil and the amount of pressure to use. These details are important for achieving the desired results. For example, drawing a very smooth texture, like satin, requires a very sharp point and light pressure, while drawing a very rough texture, like rough bark, is most successful with a dull point and medium pressure.

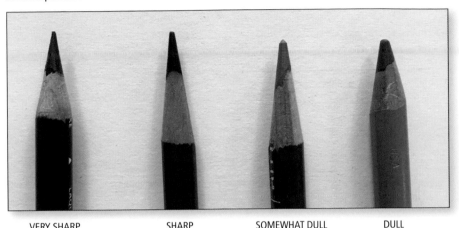

| VERY SHARP | SHARP | SOMEWHAT DULL | DULL |

SHARPNESS SCALE	
VERY SHARP	A needle-like point
SHARP	Fresh out of the sharpener
SOMEWHAT DULL	After the pencil has been used for a few minutes
DULL	A very rounded point

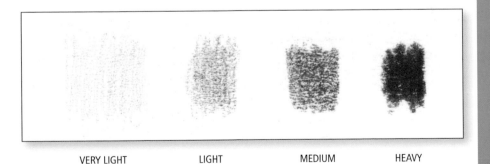

| VERY LIGHT | LIGHT | MEDIUM | HEAVY |

PRESSURE SCALE	
VERY LIGHT	Barely touching the paper
LIGHT	Gently touching the paper
MEDIUM	Normal, as for handwriting
HEAVY	Pressing so hard that the tooth of the paper is flattened

Strokes

HATCHING Hatching entails drawing parallel lines close together with a smooth back-and-forth motion. By keeping the pressure constant as you move across an area, you can create an even area of color. By keeping the pressure constant and staying in an area, you can build up more pigment coverage without prematurely flattening the tooth of the paper.

CROSSHATCHING Crosshatching is hatching in more than one direction, so that the strokes cross, to reduce the linear appearance. Sometimes this is taught as crossing strokes at a perpendicular; however, when working with colored pencils, this can result in a weave or waffle appearance, which only worsens as you try to fill the gaps. I suggest crossing strokes at a shallow angle, 30 degrees or less.

TAPERED A tapered stroke begins with a certain amount of pressure and, as you move the pencil, you apply less pressure until it is lifted away from the surface. This is useful for drawing things like eyelashes, clumps of grass, and short fur.

CIRCULAR/SCUMBLING By holding a very sharp pencil nearly vertical and moving the point in tiny, overlapping circles or ovals, the pigment can get fully down into and around the tooth of the paper to create very smooth, complete coverage that reveals no stroke direction. You can visualize this as how water fills all the spaces around rocks in a shallow pool.

BLUR A soft blur is easy to achieve if you remember that $1 + 1 = 2$ and $1/2 + 1/2 = 1$. If you partly overlap two full-strength areas of color, the area of overlap will be obvious because it has twice as much pigment, and it won't be soft. But if you fade out Color A by half and Color B by half, so that the area of overlap is the half-strength of each, you'll achieve a soft blur.

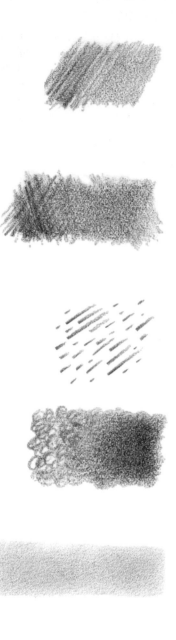

Effects

IMPRESSED LINES Impressing lines into your paper with a stylus before you begin drawing puts the indentations out of reach of pencil points. As you draw over them, they remain white. This is useful for depicting whiskers, single-hair highlights, distant twigs, and more.

WASH A wash is a thin, smooth layer of color. When working with colored pencil, the first step is often to draw a wash with white or another very light color. This provides a base color, as well as a waxy base for smoother blending of the darker colors to follow. A wash can also be a thin layer of color applied on top of another color to create a new color from the combination.

BLENDING Each strip is identical layers of crimson lake and indanthrone blue, applied more heavily at the left and transitioning to a thin wash at the right. Note the increase in color saturation when either a colorless blender or solvent is used, but also note that they can't work as well when the pigment is thin.

OPTICAL Gently drawing one layer of colored pencil on top of another produces an "optical blend." To the unaided eye, it appears to be a blend of the two colors, but viewing it through a magnifying glass reveals individual particles of each color and speckles of bare paper. It can also be considered a transparent blend. This is the most common way to blend colored pencil colors. Many people prefer this result because it looks "like a drawing."

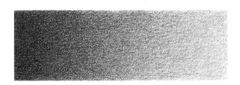

COLORLESS BLENDER When used as the last step of the drawing process, a colorless blender intensifies the colors and creates a smoother appearance. How smooth depends on how much pigment is on the paper and how hard you press. It works best with at least a couple of light layers of pigment. Pressing very hard with it is called *burnishing*. This obliterates the tooth of the paper, making the drawing a bit shiny and further adjustments difficult to impossible.

SOLVENT You need at least a couple of layers of pigment on your paper in order for there to be enough wax binder to dissolve for solvent to be effective at creating smooth color. An eyedropper-full of alcohol or odor-

less mineral spirits applied with a 1/4" flat brush is enough for a 3" x 3" square. Moisten only the tip of the brush, or blot excess on a tissue, and then touch it to your drawing. Gently stroke the pigment just enough to see it dissolve, and move on. Allow at least 15 minutes for it to fully evaporate before drawing more on top. Solvent can be reapplied after every couple of layers.

Color Mixing

Regardless of the size of your pencil collection, you probably won't have exactly the right color for every situation. Even if you did, it would look better and richer with another color added. Learning how to "see" the individual colors in your reference, and knowing what colors to combine to achieve that color, takes observation and practice—and it starts with basic knowledge of color theory.

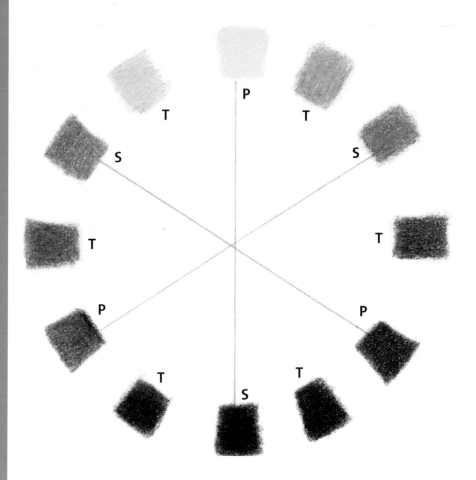

P = Primary color, S = Secondary color, T = Tertiary color. The color opposite a given color on the wheel is its direct complement. In this diagram, each primary is connected to its direct complement.

When working with pigments, there are three primary colors: red, yellow, and blue. Mixing these produces the secondary colors: orange, green, and purple. Mixing primary and secondary colors produces the tertiary colors, such as red-orange and blue-green. Drawing a color wheel with your pencils makes this easier to understand. The direct complement of a color is directly across from it on the color wheel; for example, blue and orange. Analogous colors are any three adjacent colors, such as red-orange, orange, and yellow-orange.

Placing direct complements next to each other produces vibrant contrast; mixing them produces neutral, gray/brown colors. This can also produce a more convincing "dark." For example, when drawing a red apple, the dark side is made more convincing not by using a darker red or adding black to it, but by drawing a layer of green first (an underpainting), followed by red. Experiment with layering various colors on top of each other in different concentrations to see what interesting new colors develop!

WARM VS. COOL COLORS Warm colors are yellows, oranges, and reds, associated with fire, heat, and warmth. Cool colors are blues, purples, and greens, associated with water, sky, ice, and cold. In the real world, distant objects, such as mountains and forests, appear lighter and bluer in daylight, due to the atmosphere. Foreground features appear darker, so in general, we use cool colors to suggest distance and warm colors to suggest nearness.

VALUES Value is the degree of lightness or darkness of a color. For example, yellows and light blues are light in value, while earthy browns and deep purples are dark in value. In a black-and-white image, the range of grays from white to black are its values. Your drawing needs to consist of a full range of values to look three-dimensional; if the value range is too narrow, it will look flat and washed-out. Familiarize yourself with the range of values represented in your pencil collection by way of a swatch chart.

The first thing I do before I pick up a colored pencil is identify the absolute darkest dark and lightest light areas in my reference. Then I know that all the colors I choose and create must be between those values. If you're unsure, convert your reference photo to grayscale on your computer to make the values easy to see. If you need to check your drawing's values, view it through a sheet of red acetate. The red makes all colors appear as shades of gray. If you don't have red acetate, try squinting your eyes, which subtracts a lot of detail.

ARTIST TIP

I almost never use black in my work, because it's dull and lifeless. You can create a much richer deep, dark black by heavily layering a very dark red (crimson lake), a very dark blue (indigo blue), and a very dark green (dark green). The order doesn't matter. If it looks a little greenish or bluish, add more red, and vice versa, until it becomes very dark. If it's still not dark enough to suit you after that, then add a little black.

PEOPLE

Smooth Skin

1

STEP ONE The keys to achieving smooth skin are very sharp pencils, very light pressure, adding several layers of color in light washes, and patience. For this example of golden, tan skin, start with a light outline and a wash of jasmine.

STEP TWO Add a wash of rosy beige over the jasmine. If any blobs of pigment appear, dab them off with poster putty pinched down to a tiny point the size of the blob.

STEP THREE Add a wash of peach over the rosy beige.

STEP FOUR Add a wash of goldenrod over the peach and a wash of burnt ochre over the goldenrod in just the warmest areas of skin. Add the shadow area under the jaw and on the neck with burnt ochre and sienna brown, using light pressure. If necessary, return to previous colors to even out the overall tone and increase contrast. Use cream or a colorless blender to smooth any roughness in the darker tones.

STEP FIVE This step is optional. Moisten a brush or cotton swab with odorless mineral spirits and apply it overall to dissolve the wax away. If any blotchiness results, even it out with very light touches of the predominant color of that location.

2 | Aged Skin

STEP ONE Aged, wrinkled skin is surprisingly easy to draw, because it tends to have an uneven texture and color. Begin with a light outline of the major wrinkles and an allover, medium layer of cream.

STEP TWO With a sharp point and light pressure, apply an allover layer of beige. Then use very sharp sienna brown and medium pressure to define the major wrinkles. Use the sienna brown with light pressure to draw the shadow edge of these wrinkles, stroking in the same direction as the wrinkle lines.

STEP THREE With very sharp dark umber and medium pressure, enhance the depth of the most pronounced wrinkles. Use sharp terra cotta and light pressure to further form the shadow edge of the major wrinkles and to create minor wrinkles by drawing their shadow edges, taking care to avoid applying any more pigment to the lighted edges of any wrinkles.

STEP FOUR Continue adding smaller and smaller wrinkles, as in the previous step, with sharp terra cotta and very light pressure. Add some uneven color between wrinkles with terra cotta and sharp rosy beige, using very light pressure. Finish by lightly enhancing or extending some of the existing creases.

3 Straight Hair

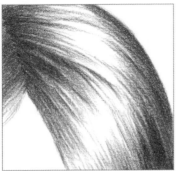

STEP ONE Straight hair is very easy to draw, because all the strokes are straight, following the direction of the hair growth. For this example of dark brown hair, begin with sharp chocolate. Make each stroke outward from the part or upward from the bottom, applying pressure from heavy to light as you approach the highlights. Vary the stroke lengths, and create gaps and darker sections to represent strands. Reserve bare paper for the brightest highlights.

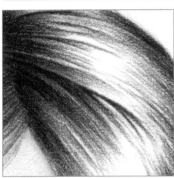

STEP TWO Repeat the previous step with dark umber, allowing some of the chocolate to remain exposed.

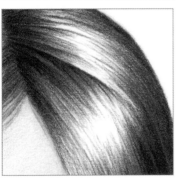

STEP THREE Repeat the first step again with light umber. Bring some strokes farther into the highlights.

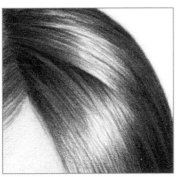

STEP FOUR Use sharp black with light-to-medium pressure to darken some of the gaps, and with very light pressure to suggest individual hairs in the highlights. To finish, touch up any strands or gaps where you'd like to have more color or contrast.

4 Curly Hair

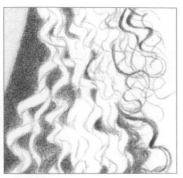

STEP ONE Curly hair can be intimidating, because each strand is a complex spiral, and many strands together form a tangle of overlapping spirals. The key is to divide and conquer, working from major shapes to minor shapes. For this dark golden blonde, begin with sharp chocolate to outline the most prominent spiral strands, fill the largest dark areas behind them, and draw some of the flyaway strands.

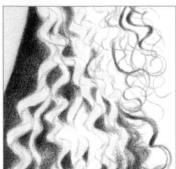

STEP TWO Note that the highlights on the major curl strands are where the light hits most directly. Use sharp cream with medium pressure to place these highlights. Further darken the dark areas with sharp dark umber and medium pressure; allow it to be uneven, since there is hair in the dark areas too. With very light pressure, use dark umber to emphasize some flyaway strands.

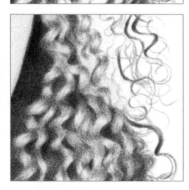

STEP THREE Apply very sharp burnt ochre with light pressure between the highlights on the major curl strands, where the light hits indirectly; stroke in the same direction as the hairs, into the cream. Use it with very light pressure to give color to some of the flyaways, and with heavy pressure in the dark areas.

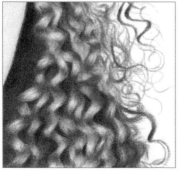

STEP FOUR Use sharp goldenrod with medium pressure on top of the burnt ochre on the strands, stroking in the same direction as the hairs. Then use sharp light umber with medium pressure just at the spots on the strands where the light hits the most indirectly. Use both the sharp goldenrod and light umber with light pressure to draw more flyaway curls. Finish by sharpening the boundaries of the major strands with very sharp raw umber and medium pressure, and, if desired, use a colorless blender with heavy pressure for a smoother look.

20

5 Wavy Hair

STEP ONE Wavy hair requires all strokes to curve in the direction of the hair. For this auburn example, begin with a light outline and a medium layer of cream where the highlights will be. Use sharp chocolate and medium pressure to define the largest gaps behind the strands, and light pressure to block in the areas between the highlights. Allow it to overlap the cream a bit, with very light pressure.

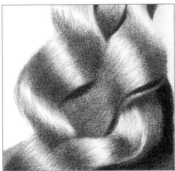

STEP TWO Use sharp terra cotta and light pressure on top of the chocolate on the strands, with more coverage where the light is the most indirect. Allow it to overlap the cream a bit farther than the chocolate. Add a layer of dark brown on top of the chocolate in the gaps.

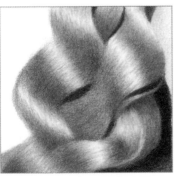

STEP THREE With colored pencil work we normally work from light to dark, but this is one instance when adding light over dark works well. Use sharp beige with medium pressure over all the hair, except the brightest highlights, to blend the previous layers together. If you wanted to depict blonde hair, this would be a good stopping point after drawing some individual hairs in the strands.

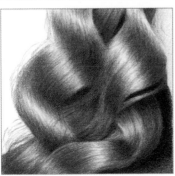

STEP FOUR Use very sharp terra cotta and light pressure again to add redness to the waves and suggest individual hairs in the strands. Use very sharp dark brown and light pressure again to add contrast to the darkest parts of the waves and suggest individual hairs in the strands. Finish by adding a few flyaway hairs with very sharp chocolate and very light pressure and by sharpening the boundaries of the waves as needed.

21

6 Facial Hair

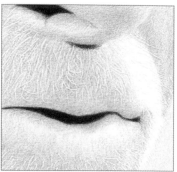

STEP ONE Coarse whiskers are easy to create using a stylus. Start with a basic outline, and then impress short whisker marks into the paper with a stylus, some straight, some slightly curled. They're easier to see with a strong light across the surface. Apply a light wash of jasmine over all the skin, except the highlight areas, and another wash of rosy beige over the jasmine. Use sharp black and heavy pressure to fill the nostril and open mouth gap, and medium pressure for the dark shadow under the nose. Fill the background with sharp sky blue light, using light pressure.

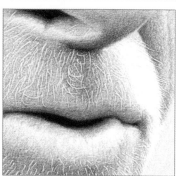

STEP TWO Use sharp sienna brown and light pressure on top of the rosy beige, with more coverage on the underside of the nose, under the nose, the underside of the top lip, under the bottom lip, and on the cheek crease. Note that the white whiskers are becoming visible.

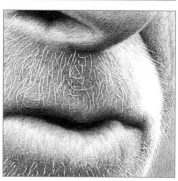

STEP THREE Use sharp Tuscan red and light pressure on top of the sienna brown and in the same manner as the previous step. Use it with very light pressure to add some creases in the lower lip. This man's coarse, ruddy complexion requires no painstaking smooth blending. Add a medium layer of slate gray to the background.

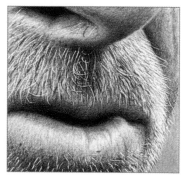

STEP FOUR Use sharp dark umber and light pressure to increase the contrast on the underside of the nose, under the nose, under the lower lip, and along the cheek crease. Then use it with very light pressure in the whiskers next to the cheek crease to suggest other whiskers. With very sharp black and medium pressure, apply short, individual strokes to create coarse black whiskers among the white ones to render a salt-and-pepper look. If desired, use a colorless blender to smooth the skin tones, but avoid the black whiskers.

Eye

STEP ONE The keys to drawing an eye correctly are to re-member that the iris and pupil are perfectly circular, the pupil is exactly centered in the iris, reflections curve with the surface of the lens, and the iris usually contains multiple colors. Begin with a basic outline and a light layer of cream on the flesh, iris, and inner corner. Apply a light layer of white on the eyeball. Reserve the bare paper for the reflection, since it is lighter than the white of the eyeball.

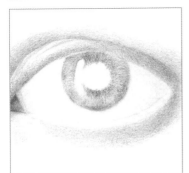

STEP TWO Add a wash of light peach all over the flesh, and then begin to model the eyelids and inner corner with sharp nectar and light pressure. Apply some initial, even color to the iris with sharp jade green and light pressure, followed by un-even color radiating from the pupil and inside border of the iris with very sharp burnt ochre and light pressure. Use warm gray 10% and very light pressure on the inside corner and outside half of the eyeball, with more coverage closest to the corners. Add a bit of carmine red to the innermost corner.

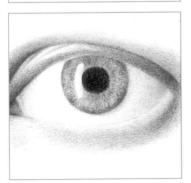

STEP THREE Use sharp henna and light pressure to further model the crease and eyelids, followed by sharp peach and light pressure to blend it a bit, finishing with very sharp dark umber with light pressure to draw the line of the crease. On the iris, add touches of sharp jasmine with light pressure on top of the burnt ochre. Also on the iris, darken the inside bor-der and radiate some marks toward the pupil with very sharp indigo blue and light pressure. Fill the pupil with sharp dark umber and heavy pressure. Use very sharp warm gray 30% and very light pressure to further model the inside corner and outside half of the eyeball.

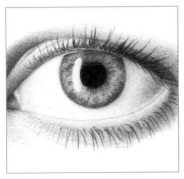

STEP FOUR Use sharp terra cotta and light pressure to finish modeling the eyelids. On the iris, radiate more burnt umber in the same locations as you did in step two. Add more touches of indigo blue to the iris, and give final definition to its border with both indigo blue and dark umber. Fill the pupil with sharp black and heavy pressure on top of the dark umber. Finish modeling the eyeball with warm gray 70% at the outside corner. Finish by drawing the eyelashes with very sharp dark umber and light-to-medium pressure. If necessary, soften the border of the iris with a little bit of white drawn around the edge.

8 Nose

STEP ONE Each nose is a little different in shape, and these differences determine the shapes and sizes of the highlights, midtones, and shadows. We need to build skin tones that depict convincing shapes. Begin with a light outline of the edge of the nose, the tip, and the nostril. Reserving bare paper for the brightest highlight, add a light wash of cream to provide a waxy base for a smooth blend of the colors to come.

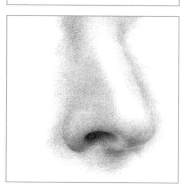

STEP TWO Draw the darkest recess of the nostril with dark umber and the darkest area under it with sharp henna and light pressure. Add a second layer everywhere else, again reserving the highlight, with sharp peach and very light pressure.

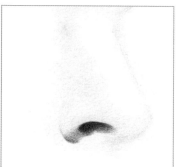

STEP THREE Use sharp nectar and very light pressure to build the shape of the nose, with more coverage under the tip and around the curl where it meets the cheek. Further darken the area under the tip and the curl with sharp henna and light pressure. Note that the edge of the nose is indistinct at this angle, and the highlight is not at the edge.

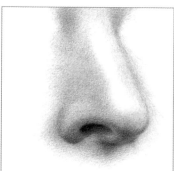

STEP FOUR Despite warm light, some areas have cooler, pinker tones. Use sharp rosy beige and light pressure to hint at these tones along the edge, around the tip and nostril, and next to the eyes. Further darken around the nostril and under the tip with very sharp dark umber and very light pressure. Finish by using cream again to very lightly blend away any roughness.

9 | Lips

STEP ONE Natural, unpainted lips have soft boundaries and many subtleties of color. Begin with a very light outline and a light wash of cream to provide a waxy base for a smooth blend of the colors to come, reserving bare paper for the brightest highlight.

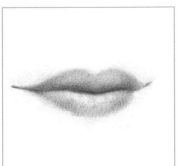

STEP TWO Draw the line where the lips meet with dark umber, darker at the corners. Add a second layer around the mouth with sharp peach and light pressure. Lightly wash the lips with sharp pink rose and pink. Use sharp carmine red with light pressure along the bottom of the upper lip, and add a few touches of it on the fullest part of the lower lip.

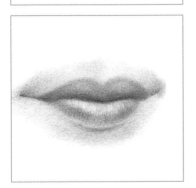

STEP THREE The area around the mouth helps shape the lips. Use sharp nectar and very light pressure as a third layer, with more coverage at the corners, under the center of the bottom lip, and above the center of the top lip. Use it with very light pressure to continue forming the lips; this will also help unify the colors.

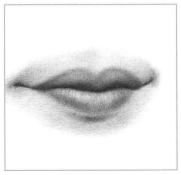

STEP FOUR Use very sharp henna and very sharp terra cotta with very light pressure to further deepen the color on the lips, along the bottom and near the upper boundary of the upper lip, and in the fullest part and underneath the center of the lower lip. Use very sharp dark umber with light pressure to sharpen the line of the mouth. Finish with very sharp pink rose and very light pressure to create the natural creases in the lower lip.

ANIMALS
& INSECTS

10 Smooth Canine Fur

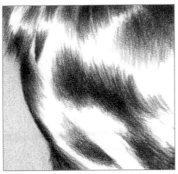

STEP ONE Smooth dog fur is easy to draw. The key is to always stroke in the direction of the hair growth, toward the highlights. For this black Labrador Retriever, begin by blocking in the darkest areas with sharp black, applying medium pressure at the beginning of strokes and light pressure at the end.

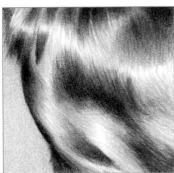

STEP TWO Add a silvery sheen to the coat by making strokes with very sharp cool gray 30% and light pressure in the highlights, overlapping the black a little.

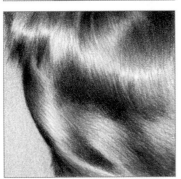

STEP THREE Sometimes there are hints of color in the highlights of black fur. In this case, add a few light strokes with very sharp dark cherry throughout the highlights. Make strokes with very sharp cool gray 70% and medium pressure as a transition between light and dark areas.

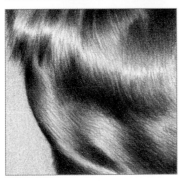

STEP FOUR Increase the contrast by adding more black with medium pressure in the darkest areas. To finish, use very sharp black and light pressure to draw some individual hairs in the highlights.

11 Curly Canine Fur

STEP ONE Curly dog fur may seem daunting because of the overlapping tangled spirals. The key is to divide and conquer, starting with the major curls and adding detail as you go. This technique does require patience! For this example of a blonde Cocker Spaniel, begin with a light outline and a light wash of cream to provide a waxy base for blending the colors to come. Then use sharp jasmine with light pressure to block in the areas between the major curls.

STEP TWO Use sharp dark brown and medium pressure to block in the darkest areas, which are behind multiple layers of curls.

STEP THREE Use sharp light umber and medium-to-light pressure to expand out from the dark umber spots, creating midtones between the major curls. Note that your curls don't have to exactly match your reference to look like curly fur.

STEP FOUR Apply burnt ochre to add some warmth to the midtones. Use it very sharp with light pressure on the background curls, at the borders where curls go underneath, and on the major curls where the light is indirect. Also, add more sharp jasmine with medium-to-heavy pressure on top of the burnt ochre, and with very light pressure to give final color to the major curls. Finish by sharpening the major curl boundaries and adding a few very light strokes of very sharp light umber and dark brown to suggest individual hairs in most of the curls.

12 Coarse Canine Fur

STEP ONE Coarse dog fur has no sheen and clumps in tufts, so it doesn't require a base layer or smooth blend. Make all strokes with very sharp pencils and light pressure in the direction of the tufts of fur. Rather than drawing a tuft directly, draw its base and/or the shadow under its tip. Start with raw umber to plan the locations of the bases and tips of the tufts.

STEP TWO Use peach beige to give a hint of color to the tips of the tufts. Then use French gray 20% to suggest a few hairs in the middle of some tufts.

STEP THREE Use both French gray 30% and French gray 70% to suggest more hairs in the tufts. Also, use French gray 70% to further darken the bases of some tufts.

STEP FOUR Finish with dark brown to accentuate the bases and shadows of some tufts even more, and add a few hairs—or rather, the shadows of hairs.

13 Canine Eye

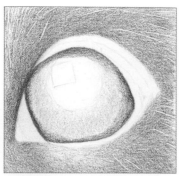

STEP ONE At first glance most dogs' eyes seem simply brown, but they actually contain several colors, just like brown human eyes. For this example, start with a basic outline, and impress a few hair lines with a stylus so that they'll remain white as colors are added. Apply a light layer of sharp yellow ochre to the iris, a light layer of sharp powder blue to the inside corner, and a light layer of sharp chocolate around the inside rim of the iris and on the skin.

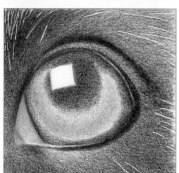

STEP TWO Use sharp dark umber with light pressure on top of all the chocolate and on the pupil, reserving bare paper for the square highlight. Use it with medium pressure in the eyelid creases. Add sharp grayed lavender with medium pressure on top of the cloud blue in the inside corner, and add a little sharp nectar to define the innermost corner membrane. Add a light layer of sharp burnt ochre in the iris.

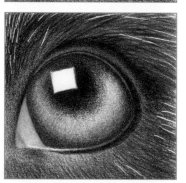

STEP THREE With very sharp warm gray 50% and black, add all the hairs around the eye—short and fine underneath with medium pressure, longer and thicker above with heavy pressure. Use sharp black with heavy pressure in the pupil, but keep the edge indistinct. Use sharp terra cotta and Tuscan red with light pressure around the pupil and inside the border of the iris with medium pressure.

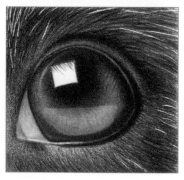

STEP FOUR Use sharp dark umber again, with medium pressure, to blend the pupil into the iris and around the inside edge of the iris. Use very sharp black to add more hairs as needed and create contrast in the eyelid creases. Use a colorless blender to smooth the iris. Then use white with light pressure to add a curved highlight next to the square one and in the lower half of the iris to suggest reflection of the landscape. Finish by using very sharp dark umber and light pressure to add the reflections of the eyelashes in the square highlight and the iris.

Long Cat Hair

STEP ONE The keys to drawing long, soft cat hair are to always keep your pencils very sharp and make all strokes in the direction of the hair growth. Rather than drawing strands directly, draw the areas where other strands go under them. For this ginger cat, begin with a light layer of yellow ochre, planning the location of the strands with more coverage.

STEP TWO Use burnt ochre and light-to-medium pressure to begin defining the dark areas under the strands. Suggest some individual hairs with light pressure.

STEP THREE Add mineral orange with light-to-medium pressure on top of the burnt ochre, and suggest more individual hairs with light pressure.

STEP FOUR Use sienna brown with light pressure to suggest a few individual hairs, with medium pressure to increase the contrast around minor strands, and with heavy pressure for the darkest areas behind the layers of hair. Finish with touches of goldenrod and light pressure to yield the final ginger color, and use a colorless blender to smooth any roughness as desired.

15 Short Cat Hair

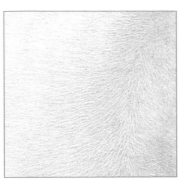

STEP ONE The keys to drawing short cat hair are to always keep your pencils very sharp and make all strokes very short and in the direction of the hair growth. An Abyssinian's "ticked" coat (in which hairs have bands of color), calls for all-over short flecks of color. Begin by impressing very short lines in the paper with a stylus—these will become the highlight hairs as color is added. Use sand with light pressure to create a smooth base layer.

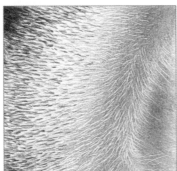

STEP TWO Use mineral orange with light pressure as a second smooth layer where the contour curves. Use dark umber to begin evenly adding dark hairs with medium pressure and very short strokes.

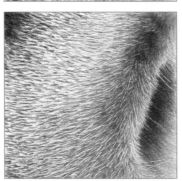

STEP THREE Continue adding very short strokes of dark umber. Draw longer, smooth strokes in the deep fold where the hairs are not ticked, and add a few strokes on the contour to suggest gaps. Use very short strokes of burnt ochre with medium pressure as a third layer on the contour, and with longer, smooth strokes in the deep fold.

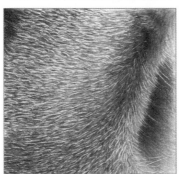

STEP FOUR Continue adding very short strokes all over with previous colors, as well as with chocolate and light umber. Aim to create a gradual transition with the marks, from cooler and browner at the left edge to warmer and redder at the contour. Finish with more mineral orange at the edge of the contour.

16 Cat Eye

STEP ONE Wildcat eyes have round pupils, and domestic cat eyes have slit pupils. Some cat eyes change color slightly from day to day. Begin with a basic outline and a light layer of ginger root all around for the fur and a light layer of chartreuse for the iris; reserve bare paper for the highlight reflection.

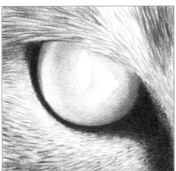

STEP TWO Use very sharp light umber and dark umber with light pressure and short strokes to indicate the fur. Note that the hairs above the eye are longer than those below the eye. Use light umber with light pressure around the left and right inside border of the iris and a bit to the left of the pupil. Use dark umber with medium pressure around the under-eye rim and inside corner. Add a very light layer of jasmine to the iris.

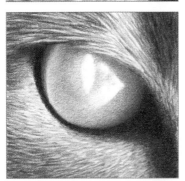

STEP THREE Use very sharp sienna brown and chocolate with light pressure and short strokes to indicate more hairs. Use very sharp marine green with light pressure to adjust the color of the iris, applying more coverage under the brow and at the inside corner.

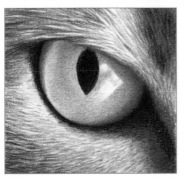

STEP FOUR With sharp black and heavy pressure, fill the pupil and increase the contrast around the rim and inside corner. Use light pressure to add a few hairs. Then use very sharp mineral orange with light pressure to add a few more hairs. Use sharp dark umber with light pressure on the iris under the brow to increase the contrast there. Add more chartreuse to the iris if needed. If desired, finish by smoothing the iris with a colorless blender, avoiding the edges of the pupil and rim.

17 Horse Coat

STEP ONE A horse's coat is very short, flat, and glossy, which enhances its muscles. Keep your pencils very sharp, and make all strokes very short and in the direction of the hair growth, which generally follows the horse's anatomy. You only need three colors for this example. Begin with mineral orange and light pressure. Indicate just a few hairs in the glossy area, and transition to more coverage where the coat is darker

STEP TWO Use terra cotta in the same manner. Add more coverage in the areas that will be darker in value.

STEP THREE Use dark brown with medium pressure to fully define the dark value areas, and fade to light pressure for a soft transition.

STEP FOUR With medium-to-heavy pressure, keep adding terra cotta strokes in the dark areas and mineral orange strokes in the areas between until the rich color is fully developed. If desired, finish with a colorless blender to reduce speckles, but allow the slight roughness in the glossy area to remain—it suggests sparkle in the gloss.

18 Horse Mane

STEP ONE The main difference between a horse's mane and a human's hair is that the mane is coarser. It flows similarly, but the strands stand apart more. For this blonde Palomino, start with a basic outline of the flowing strands and a light overall layer of cream to provide a waxy base for a smooth blend of the colors to follow. The highlights will remain this color.

STEP TWO Make all your strokes in the direction of the strands. With sharp yellowed orange and light pressure, begin to indicate where layers of strands overlap, as well as the flyaway tips, which are darker away from the highlights. Use more coverage as the base color for the horse's neck.

STEP THREE With sharp burnt ochre and medium-to-heavy pressure, create the darkest gaps behind some of the strands. With light pressure, suggest subtle variations in the strands, and add smooth form to the horse's neck.

STEP FOUR With sharp dark brown, and heavy pressure, reinforce the dark gaps you created in the previous step. With light pressure, add a few strokes to suggest individual hairs. Add more strokes of yellowed orange and burnt ochre as needed to intensify the colors and strands. If desired, finish with a colorless blender to smooth the horse's neck and some of the strands; leave some strands rough to preserve the overall coarse-hair look.

19 Elephant Skin

STEP ONE Elephant skin is surprisingly easy to draw, despite the number of wrinkles. There are a couple of key things to note: when a wrinkle is lit from above, the top edge has a shadow above it; and when a network of wrinkles crisscross, the puffy shapes they form may have shadows and crinkles on all four sides. The roughness works in the artist's favor, because you don't have to spend time creating smoothness. The skin is almost entirely grays. Begin with a light base layer of sharp warm gray 10%, warm gray 30%, and warm gray 50% to indicate overall light and dark areas.

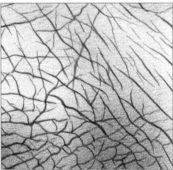

STEP TWO With very sharp black and medium-to-heavy pressure, draw the creases, varying the thickness to indicate that some are deep and some are shallow.

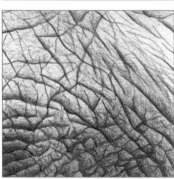

STEP THREE With warm gray 70%, draw the shadows for the creases; use light pressure around shallow creases in the light, and medium pressure around deep creases in shadow. Use light pressure to draw some crinkles in the puffy shapes, and lightly scribble in the light areas to suggest roughness.

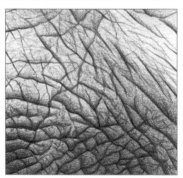

STEP FOUR A dusty elephant isn't simply gray, so use sharp sandbar brown with light pressure over most of the skin. Finish with very sharp black and heavy pressure to reinforce some of the deepest creases.

Snakeskin

STEP ONE Snake scales overlap in rows that are slightly off-set from each other, like shingles on a roof. Although they are hard and smooth, the coloration is uneven to lend camouflage, and the colors vary among individuals of the same species. For this example, begin with a basic outline of the scales.

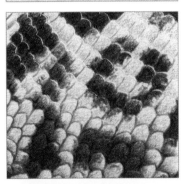

STEP TWO Use a stylus to impress curves into the paper for the highlighted edges of scales that are lit from above. Then use sharp sand with light-to-medium pressure for an allover base layer, with more coverage toward the bottom where the snake's body curves under.

STEP THREE With sharp dark umber and heavy pressure, fill in the dark scales; use heavy pressure to outline them, and medium pressure to add blotches to the scales that aren't completely dark. With sharp chocolate and light pressure, indicate the edges of all the other scales, and add a slight amount at the base of each scale where it goes under another scale. Go darker with these lines and shading toward the bottom.

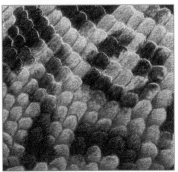

STEP FOUR Add a light layer of Spanish orange to all the light scales. Use sharp cadmium orange with light pressure to add splotches to many of them, and with medium pressure to deepen the color of the scales toward the bottom. Use sharp sienna brown with very light pressure to darken the base of all the light scales so the overlap is more obvious, applying more coverage toward the bottom. Use very sharp sienna brown with light pressure to redefine the edges between scales if needed. Finish by sharpening edges and deepening overlaps as needed.

21 Leopard Fur

STEP ONE A leopard's coat is short and flat, like any short cat hair. What makes it interesting is its spot pattern. The spots are groups of blobs shaped like "C," "I," "L," and "U," as well as dots. The space inside a group is filled with brighter color. Begin with a basic outline of the dark blobs.

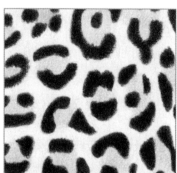

STEP TWO Use sharp ginger root with light pressure to fill the background, sharp beige with light pressure to fill the space inside each group, and sharp dark umber with medium pressure to fill the blobs. Allow the borders of the blobs to be indistinct for now.

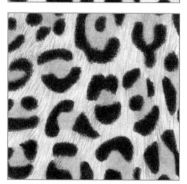

STEP THREE Use sharp sand and medium pressure on top of the beige from the previous step. With very sharp light umber and light pressure, draw short strokes in the ginger root area to suggest hairs. Note that they don't all go exactly the same direction.

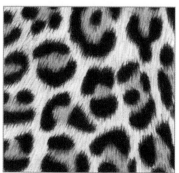

STEP FOUR Use sharp mineral orange and light pressure as a third layer of color on top of the sand from the previous step. Then, with very sharp chocolate and medium pressure, draw short strokes in those areas to suggest hairs. With very sharp dark umber and medium-to-heavy pressure, draw very short strokes up from the tops of the dark blobs and down from the bottoms to suggest overlapping hairs at the boundaries. Use dark umber with heavy pressure to fully darken the interiors of the blobs.

Fish Scales

STEP ONE Fish scales are shiny and are usually arranged in overlapping horizontal rows. For this example of a goldfish swimming to the right, begin with a light outline. Erase as much of it as you can while still being able to see it to ensure that the graphite lines won't show through the light colors to come.

STEP TWO Use sharp canary yellow and light pressure for an overall base layer, and then visit each scale with more coverage at the base where it goes under the scales to its right and below.

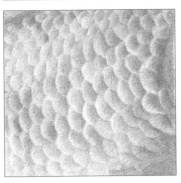

STEP THREE With very sharp yellowed orange and light pressure, enhance the base of each scale and fade the strokes outward, keeping the edges crisp. Note that there are slight variations in the colors of scales, since no two are exactly alike. Then use medium pressure around the gill at the right and along the base of the top and bottom fins.

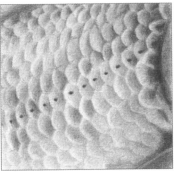

STEP FOUR With sharp cadmium orange, further enhance the bases of the scales closest to the gill and below the top fin, as well as some other scales throughout. Use medium pressure to add final brightness to the gill and the base of the top and bottom fins, and add the midline dots. Add a few touches of very sharp periwinkle on the bottom scales closest to the gill to suggest slight color variation. Smooth any roughness on individual scales with a colorless blender, and finish by sharpening scale edges as needed.

23 Feather

STEP ONE The keys to drawing feathers are to keep your pencils very sharp and to always stroke in the direction of the barbs off the shaft. For this example of a blue and gold macaw, start with a basic outline. Erase as much of it as you can while still being able to see it to ensure that the graphite lines won't show through the light colors to come.

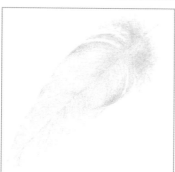

STEP TWO With powder blue and very light pressure, apply an overall base layer to the bluish areas of the feather. Do the same with goldenrod for the gold areas and cool gray 20% for the remainder. Use the cool gray 20% to draw the fluff near the base.

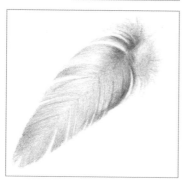

STEP THREE Draw the bluish barbs with ultramarine and very light strokes, varying the coverage so that some tips are darker and some separations become apparent. Do likewise nearer the base with light umber. Add a few light strokes of light umber in the center of the fluff.

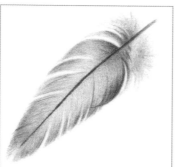

STEP FOUR Use indigo blue with very light strokes to add final color in the bluish barbs and darken some of the tips. The three blues together produce more lifelike variation than any one on its own would. Do likewise with dark umber near the base. Add more goldenrod in the gold areas and very lightly fade it along the shaft toward the tip. Finally, draw the base of the shaft with artichoke and medium pressure, and draw the remainder of the shaft with dark umber and medium pressure, tapering the width to the tip.

Butterfly Wing

STEP ONE Butterfly wings are complex in structure and pattern. They aren't flat—the rigid veins and papery sections are like the ribs and cover on a hang glider. Seemingly flat areas of color are usually not, and spot sizes, shapes, and colors vary among individuals of a species. For this example of a male monarch, begin with a basic outline.

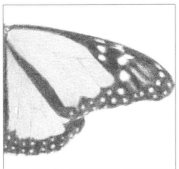

STEP TWO For the first layer of color, use sharp sunburst yellow with light pressure throughout the sections, and light umber with light pressure for medium coverage in the margins. Don't draw the veins yet—save them until last to ensure they stay crisp.

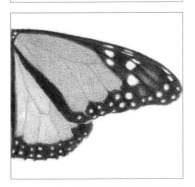

STEP THREE By building multiple layers of color, the result will be more lifelike. For the second layer, use sharp mineral orange with light pressure throughout the sections, and sharp dark umber with medium-to-heavy pressure in the margins. Go over the veins in the margins with especially heavy pressure to make them visible. Use more mineral orange on the forewing than the hindwing.

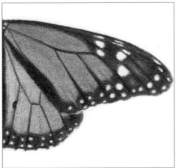

STEP FOUR For the final layer of color, use sharp Spanish orange and medium pressure on the sections. Then draw the veins and pheromone spot with very sharp dark umber and medium pressure, noting that the veins grow slightly wider toward the outside half of the forewing. Finally, use very sharp pale vermilion and light pressure around the inside edges of each section, and add a few strokes midway between the veins to suggest the slight ripple in the sections. Clean up the edges as needed.

25 Spiderweb

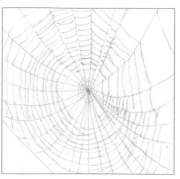

STEP ONE The shape, size, and structure of a spiderweb varies by the spider species and individual spider—no two webs are alike. Almost nothing is easier to draw than this example by a garden spider! Begin with a graphite outline of the web, and use it as a guide to impress the lines into the paper with a stylus. Then erase all the graphite, pressing your kneaded eraser into the lines to ensure you remove it all.

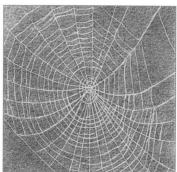

STEP TWO At this point you've actually already "drawn" the web, and you need only to make it appear with layers of color. Whatever colors you choose, use light pressure to build coverage, so as not to mash the paper down to the impressed lines and pollute them. For the first layer use sharp kelp green all over.

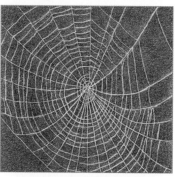

STEP THREE For the second layer of color, use sharp black cherry with light pressure on top of the kelp green from the previous step.

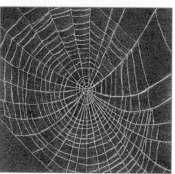

STEP FOUR For the third layer of color, use sharp indigo blue with light pressure on top of the black cherry from the previous step. If desired, continue with other colors.

FABRICS & TEXTILES

26 Burlap

STEP ONE Burlap is a loose weave of very coarse jute threads of varying thicknesses, so precision is unnecessary. The hardest aspect is the first step—drawing the outline of the basic basket-weave pattern correctly, with gaps between the threads.

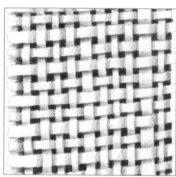

STEP TWO Use sharp dark brown with heavy pressure to fill the rectangular gaps between the threads. Then use sharp light umber and light pressure to define where each thread passes under another, crisp at the edges and faded toward the center of each section.

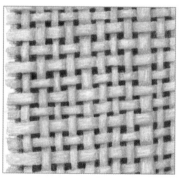

STEP THREE Now that the weave is defined, use sharp seashell pink and light pressure to color the threads; stroke in the direction of each thread so they begin to look fibrous. Then use medium pressure along the bottom side of each horizontal thread and along both sides of each vertical thread to give them a more rounded shape.

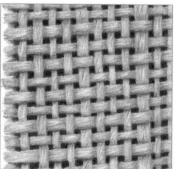

STEP FOUR Use very sharp sienna brown and light pressure to stroke a few fine lines in the same direction as the threads to suggest fibers. Use this pencil to further define the rounded form of the threads and draw crisper edges where they pass under each other.

Wool

STEP ONE For this example of a close-up of the thick herringbone stitches in a turquoise wool knit sweater, begin with a basic outline of the stitches.

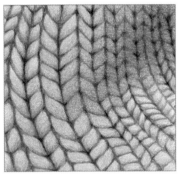

STEP TWO With sharp indigo blue and medium pressure, outline the stitches so that the points pull down and the edges are slightly rounded. With light pressure, shade the lower part of each stitch to begin giving it form, and shade the shadow from the fold in the fabric.

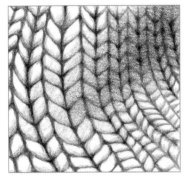

STEP THREE With light aqua and light pressure, add color to all the stitches, stroking in the direction of the yarn in each stitch. Create more coverage in the fold and less in the lit area below it. Use medium pressure on top of the indigo blue lines and shading.

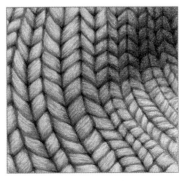

STEP FOUR Use cobalt turquoise and light pressure to stroke a few fine lines in each stitch, working in the same direction as the yarn, to suggest wool fibers. Use medium pressure to further define the underside and bottom edge of each stitch. Use indigo blue, again with medium pressure, to increase the contrast of the fold and the edges of the stitches. Then use light pressure to stroke a few fine lines in some stitches to suggest more fibers. Finish with very sharp black and heavy pressure just at the intersections of most sets of four stitches to increase the contrast.

28 Tweed

STEP ONE Tweed is a thick, woven wool fabric with a fine herringbone pattern in earth tones, usually with very subtle windowpane stripes of other colors. For this example, begin with an outline of the herringbone pattern; note that the ribs are offset from each other.

STEP TWO Use sharp peach beige with light pressure for an allover medium base layer. Allow the appearance to remain a bit rough, which will contribute to the woolen appearance.

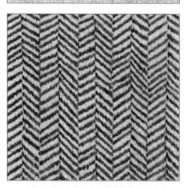

STEP THREE With sharp dark umber and heavy pressure, draw the herringbone ribs in very short, vertical strokes. They don't need to be perfect.

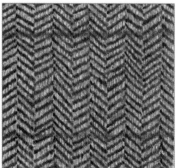

STEP FOUR Use sharp chocolate with light pressure to add very small vertical strokes between the dark herringbone lines, to suggest threads in the weave. Finish with sharp terra cotta and sharp Caribbean sea with medium pressure to add the subtle horizontal and vertical windowpane threads.

Plaid

STEP ONE Plaid is a complex pattern, rather than a texture. There are hundreds of plaid patterns and color combinations, all based on overlapping perpendicular lines and squares with a transparent effect. Begin with a careful outline of all the lines and squares.

STEP TWO With sharp permanent red and heavy pressure, fill the four brightest squares, which are the focal point of the pattern. With light pressure, fill the four ribbons that intersect to produce those squares with a medium layer of color; be careful to avoid the stripes that will overlap them, and keep the edges crisp.

STEP THREE With sharp Prussian green and heavy pressure, fill the four squares in the very center and the sets of four squares in each corner. With light pressure, fill all the other squares with a medium layer of color. Again, be careful to avoid the stripes that will overlap them, and keep the edges crisp.

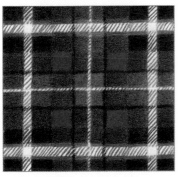

STEP FOUR With sharp black raspberry and heavy pressure, add a second layer to the set of four squares in each corner to achieve their final darkness. With light pressure, add a second layer to all the other squares, except the brightest red and green ones at the center. With heavy pressure, fill the two pairs of lines that intersect to encompass the green center. Use all three pencils (permanent red, Prussian green, and black raspberry) to carefully draw very sharp, parallel, evenly spaced diagonal lines across the remaining white stripes, according to the color next to them. Avoid the stripes' intersections, so they remain white. Finish by smoothing the layers with a colorless blender.

30 Denim

STEP ONE Denim is made in a variety of colors and washes, but they all have in common a heavy cotton weave, with noticeable vertical striations that are easy to draw. Start with a basic outline of the seams and pockets, and use very sharp indigo Blue and medium pressure to place the darkest lines.

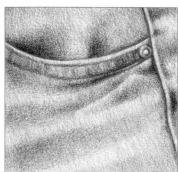

STEP TWO With sharp indigo blue and light pressure, create a monochromatic version of the jeans. Try to make most of your strokes by following the direction of the fabric, and allow your pencil to get a little dull so that the appearance is a bit grainy.

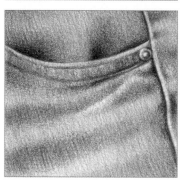

STEP THREE Use sharp cerulean blue with light pressure on top of the indigo blue from the previous step, making long strokes to suggest the striations in the fabric. Create more coverage in the folds and creases. Use sharp black with medium pressure to increase the contrast along the seam and top of the pocket.

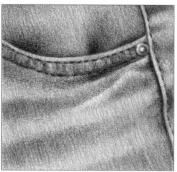

STEP FOUR With very sharp indigo blue and heavy pressure, draw the stitches with short, evenly spaced strokes. Then use it with light pressure to enhance the subtle puckers between the rows of stitches and on both sides of the seam, and adjust the contrast of the creases as needed.

Cotton

STEP ONE Depicting plain white cotton in color seems challenging, because the fabric seemingly has no color. A simple rule of thumb makes it easy: if the light is warm, the shadows are cool, and vice versa. First build the values, and then add color. Start with an overall light layer of white to provide a waxy base for a smooth blend of the colors to follow. Then use warm gray 10% and light pressure to wash over all but the brightest highlights, and place the lightest shadows.

STEP TWO Use warm gray 30% with light pressure to add midtones to the shadows and creases, and with medium pressure where the darkest shadows are.

STEP THREE Use warm gray 70% with light pressure to create contrast in the creases, and with medium pressure to create the darkest shadows. Now that the value range is complete, use cream with light pressure on the highlights to suggest that the fabric is lit by warm light.

STEP FOUR Use sky blue light with light pressure on top of the grays on the shaded side of the folds and creases. Create more coverage in the midtones and less in transitions.

32 **Silk**

STEP ONE Silk is very smooth and shiny, but not as shiny as satin. The challenge is to create the smoothness; the process isn't hard, but it is time-consuming. Begin with a basic outline of the folds and an overall light layer of white to provide a waxy base for a smooth blend of the colors to follow.

STEP TWO The highlights will be the same color as the fabric, rather than white, so with very sharp hot pink and light pressure, create an overall medium wash. Make it as smooth and even as you can, which will help make the following applications of color smooth as well. If any blobs occur, dab them off with poster putty, rather than trying to continue over them.

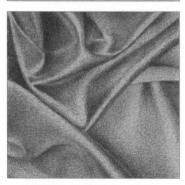

STEP THREE With sharp process red and heavy pressure, draw the darkest creases and folds. Then, with medium-to-light pressure, model all the other folds and creases. This is now a complete, but monochromatic, drawing.

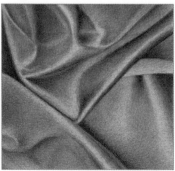

STEP FOUR For final contrast, use very sharp black grape with medium pressure in the deepest creases and folds. Use it with very light pressure to add depth around some of those creases and folds. Finish with sharp white and light pressure to smooth any roughness in the highlights, and then smooth all over with a colorless blender.

Satin

STEP ONE Satin is slippery-smooth and so shiny that its highlights appear white. Where they aren't highlighted, the folds reflect light from neighboring folds, so the darkest part is a band in the center of the shaded side, rather than the entire shaded side. For this example, begin with a very basic outline of only the major folds so the lines won't show through the light colors. Then apply an allover light layer of white to provide a waxy base for a smooth blend of the colors to follow.

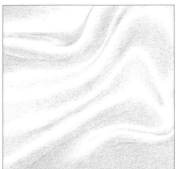

STEP TWO Working from light to dark will help create a smooth blend, so for the first layer of color, use very sharp electric blue with light pressure. Add more coverage in areas that will be darkened in later steps.

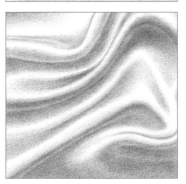

STEP THREE Use very sharp true blue with medium pressure to darken the deepest creases, and draw a stripe down the middle of the shaded side of each fold. Use it with light pressure to shade the forms between the folds.

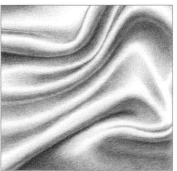

STEP FOUR Use very sharp indanthrone blue with medium pressure to add the final depth of the deepest creases. Use very sharp cerulean blue with light pressure to intensify the color between folds and the stripe down the middle of the shaded side of each fold. To finish, smooth all over with a colorless blender.

34 Velvet

STEP ONE The thick plushness of velvet lends it very rich color. This is one instance when heavier pressure and coverage works well. Begin with a basic outline of the major folds and an overall light layer of white to provide a waxy base for a smooth blending of the colors to follow.

STEP TWO With sharp permanent red and light pressure, create an overall medium wash. This is the warm undertone for the fabric.

STEP THREE With sharp pomegranate and light-to-medium pressure, smoothly model the folds, avoiding the highlight edges. Use heavier pressure in the darkest creases.

STEP FOUR Use sharp black grape and light pressure on top of the pomegranate to increase the contrast of the folds, again avoiding the highlight edges. Use medium pressure in the darkest creases. Use lemon yellow and medium pressure to draw a subtle highlight along the two brightest edges. Finish by smoothing overall with a colorless blender.

Leather

STEP ONE Tanned leather has crinkles, creases, and usually, a warm undertone. For this example, begin with an overall medium layer of eggshell to provide both the warm undertone and a waxy base for a smooth blend of the colors to follow. This layer doesn't need to be perfectly smooth, but it's good practice to do so. Use a stylus or other sharp tool with light pressure to impress a few faint crinkles, which will show up later.

STEP TWO With sharp pumpkin orange and light pressure, block in the major creases and crinkles, such as the diagonal across the center, and then the minor ones. Then shade everything else around them, gradually building the value range and slightly lumpy forms. Note that the shading is darker on the sides of the creases farther from the light source. Use more coverage where the creases are most pronounced.

STEP THREE To warm the tone more, use sharp Spanish orange and light pressure overall, except in the brightest creases.

STEP FOUR Use sharp burnt ochre with light pressure to tone down the overall orangeness a bit. As the impressed lines begin to appear, add shading to one side of them to incorporate them into the texture. Use sharp sienna brown with light-to-medium pressure to give more contrast to the darker creases, and then very sharp dark umber with light pressure for final contrast in the darkest creases. If needed, add a bit more pumpkin orange and Spanish orange in the light areas. Finish by smoothing overall with a colorless blender, being careful to work alongside creases rather than across them.

36 Sequins

STEP ONE Individual sequins are not completely flat, due to their attachment point. Depending on how the light strikes, their color may be solid or graded. This is most noticeable in the brighter—but not brightest—sequins. They overlap in various ways as the fabric moves. For this example of gold sequins, begin with an outline of most of the sequins.

STEP TWO Identify the brightest sequins, and reserve the bare paper for them. With sharp canary yellow and medium pressure, fill the second-brightest sequins. With sharp goldenrod and medium pressure, fill the third-brightest sequins. Use goldenrod with light pressure to add shading to some of the canary yellow sequins. Don't worry too much about staying within the lines in this step; you'll clean up the edges with the darker colors in the next step.

STEP THREE With sharp mineral orange and medium pressure, fill the fourth-brightest sequins. With sharp terra cotta and medium pressure, fill the fifth-brightest sequins. Use terra cotta with light pressure to slightly darken some of the mineral orange sequins. Keep the edges crisp. Fill gaps with mineral orange, and lightly add a bit of it to a few of the goldenrod sequins.

STEP FOUR With sharp dark umber and medium pressure, darken some of the terra cotta sequins to create the darkest sequins. About as many should be completely dark as are completely white. To finish, clean up edges and use poster putty to dab away any dark crumbs that have contaminated the white sequins.

Lace

STEP ONE Lace can be intimidating because of its complexity of patterns and stitches. The key is to divide and conquer, working from major shapes to details a section at a time to avoid getting lost. Start with a fairly detailed outline.

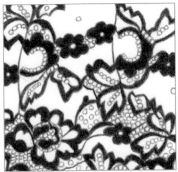

STEP TWO With very sharp indigo blue and light pressure, go over the entire outline. Then fill the solid shapes with medium-to-heavy pressure. Keep the lines and edges crisp, sharpening your pencil often.

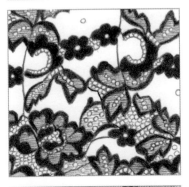

STEP THREE Continue with very sharp indigo blue and light pressure, drawing all the horizontal lines in the leafy sections. They don't need to be perfectly straight, because there are always slight imperfections in lace, but keep them evenly spaced. Note that some sections of the design have closer-spaced lines than others.

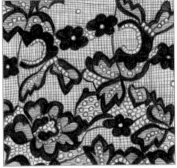

STEP FOUR With very sharp indigo blue and light pressure, draw the grid around the leafy sections. Again, perfection is not necessary, but keep the horizontal and vertical lines evenly spaced overall. Finish by outlining all the solid areas with very sharp black grape and heavy pressure.

38 Straw Hat

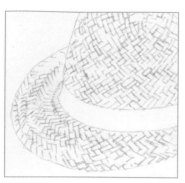

STEP ONE The weave of a straw hat can be challenging, not only because of the pattern but because it curves in multiple directions. The key is to not try to draw every strip, but to draw some and only suggest others. Begin with a fairly detailed outline of the weave.

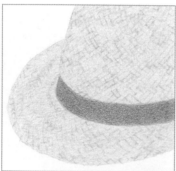

STEP TWO With sharp eggshell and light pressure, create a light wash for the straw. Do the same with nectar for the band.

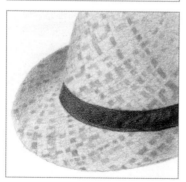

STEP THREE Use sharp yellow ochre and sharp beige sienna, both with light pressure, to give form to the hat, with even more coverage where the brim curls. Use sharp chestnut with light-to-medium pressure to give form to the band, and sharp black raspberry with medium pressure to add puckers. Then use very sharp yellow ochre, artichoke, and beige sienna, all with light-to-medium pressure, to fill some of the rectangular strips in the weave, which spiral around the hat in both directions. Try to keep the edges crisp.

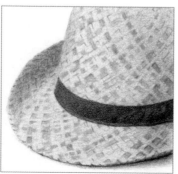

STEP FOUR With very sharp dark brown and light pressure, enhance the shadow-side edges of some of the rectangular strips and the corners where some of them cross, as well as along the edge of the brim. Finish by drawing a shadow under the hat with warm gray 20% and warm gray 90%.

Woven Basket

STEP ONE The key to a successful basket weave, regardless of the pattern, is to remember that strips are always darker where they pass under or behind, and lighter where they pass over or in front. For this example, begin with a detailed outline, and then use sharp cream for an overall light base layer. This will provide both a warm undertone and a waxy base for a smooth blend of the colors to follow.

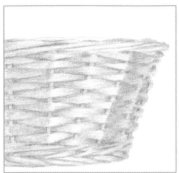

STEP TWO For the remaining three steps, always stroke in the direction of the strips. With sharp yellow ochre and light pressure, shade the strips where they pass behind or under anything, and where the basket curves away from the light source.

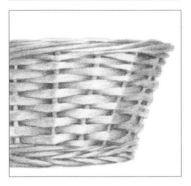

STEP THREE With very sharp burnt ochre and light pressure, further enhance the contrast where the strips pass behind or under, closer to those intersections. Keep the edges crisp.

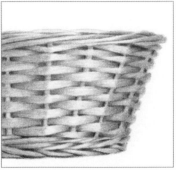

STEP FOUR Use sharp mineral orange and light pressure to blend any roughness in the burnt ochre from the previous step and create a warmer look where the basket curves away from the light source. Finish by increasing the contrast of the darkest intersections with very sharp chocolate and light pressure.

GLASS, STONE, CERAMICS, WOOD & METAL

Stained Glass

STEP ONE The challenge of stained glass is that it has very saturated color and is translucent. The keys are to start with light, bright colors before adding darker tones, and to add the very dark strips between the panes last so the edges stay crisp and dark crumbs don't pollute the panes. Begin with an outline of the panes and strips. Erase as much of the outline as you can and still see it, so the graphite lines won't show through the light colors to come.

STEP TWO For the first layer of color, keep all your pencils very sharp and apply with light pressure to get to medium coverage. Use lemon yellow, pale vermilion, hot pink, carmine red, chartreuse, apple green, light aqua, and electric blue.

STEP THREE Apply the second layer of color in indistinct blobs to suggest the outdoors on the other side of the glass. Keep all your pencils very sharp and apply with light-to-medium pressure. In the same order as the previous colors, use sunburst yellow, henna, mulberry, crimson lake, spring green, cobalt turquoise, grass green, and Mediterranean blue. To suggest textured glass, apply the mulberry and the Mediterranean blue in uneven lines, and use very sharp white with medium pressure to enhance the contrast above these lines.

STEP FOUR Finish with very sharp black and heavy pressure to draw the strips between the panes. Try to keep the edges very crisp—sharpen the pencil often. It's okay for the thickness of some strips to vary a bit, because real stained glass window strips usually vary as well.

41 Clear Glass

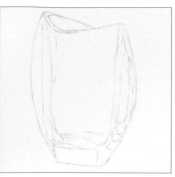

STEP ONE Clear glass is surprisingly easy to draw, by keeping track of the refraction lines and curves where light bends inside it. For this example, we'll use only cool grays to show that even with colored pencils, there are occasions when no color is needed. Start with an outline of the vase and its major refractions. Be sure to erase as much of it as you can and still see it, so the graphite won't show through the light colors to come.

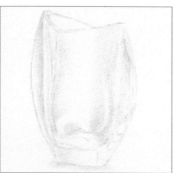

STEP TWO Reserve the bare paper for the clearest, brightest highlights. Use sharp cool gray 10% with light pressure to draw the lightest areas that are neither completely clear or highlights.

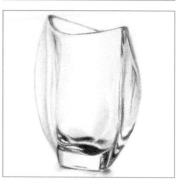

STEP THREE Use very sharp cool gray 30% with light pressure on top of some of the previous gray to increase the contrast and suggest subtle shifts in value. Use very sharp cool gray 90% with medium pressure to create the darkest areas in the base, and with light pressure to define the rim, the base where it meets the table, and some refraction lines along the sides.

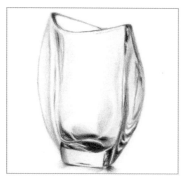

STEP FOUR Now that the lightest and darkest areas are defined, use very sharp cool gray 50% with light pressure to add the middle-value refractions along the sides and in the base. Make final adjustments to contrast in any of the grays as needed.

Translucent Balloons

STEP ONE Balloons pose several challenges when grouped together: they're very smooth, they're translucent, and they're reflective. Begin with a basic outline of the balloons, the major reflections, and the overlaps.

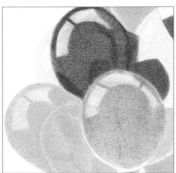

STEP TWO For the first layer, choose light, bright colors so that the end result will be bright and intense. In this example, use very sharp lemon yellow, hot pink, carmine red, spring green, and electric blue with light pressure for medium coverage.

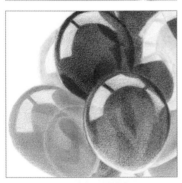

STEP THREE For the second layer, choose deeper values of the first colors: very sharp sunburst yellow, mulberry, crimson lake, grass green, and ultramarine with light pressure. Use these colors to define the darker areas with medium pressure.

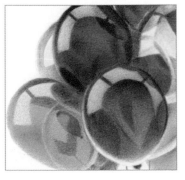

STEP FOUR Now that the basic colors of the individual balloons are established, it's time to add the reflected and transmitted colors that relate the balloons to each other. Using the same colors from the previous step, draw these areas with light-to-medium pressure. For example, the green balloon reflects onto the red balloon, so use grass green with medium pressure to draw that reflection. The blue balloon at the bottom shows through the purple balloon in front, so use ultramarine lightly on top of the mulberry to draw it. Keep all edges crisp. Finish with very sharp white to smooth the high-lights and a colorless blender to smooth everywhere else.

43 Cobalt Glass

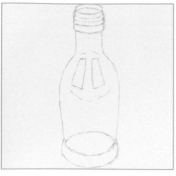

STEP ONE Like a translucent balloon, colored glass is smooth and reflective, but it's more transparent and refractive, like clear glass. For this example of a cobalt-blue bottle, begin with a basic outline of the bottle and the major reflections. Erase as much of it as you can and still see it, so the graphite lines won't show through the light colors to come.

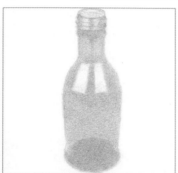

STEP TWO With very sharp light cerulean blue and light pressure, create an overall light wash, with more coverage in the areas which will be darker, such as the collar and base.

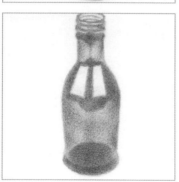

STEP THREE With very sharp cobalt blue and light pressure, enhance the more saturated color areas—the collar, base, and shoulder—with medium coverage. Use it very lightly near the edges to begin giving the bottle form.

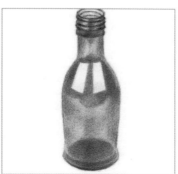

STEP FOUR With sharp violet blue and medium pressure, give final intensity to the deepest blues of the collar, shoulder, and base. Use it lightly near the edges to give the bottle its final form. Then use very sharp indanthrone blue with medium pressure to define the screw-top rings at the opening and the bottom of the base. Add hints of it in the center of the base and along the sides to enhance the transparent look. Clean up edges as needed, and finish with a colorless blender to smooth overall.

44 Porcelain

STEP ONE The challenge of porcelain is its saturated color with a very smooth, shiny glaze that produces reflections and smooth gradations. It calls for both very light and heavy layers. Begin with a basic outline that includes the reflective areas.

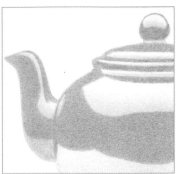

STEP TWO Use very sharp powder blue with light pressure to create a base for the gradients in the highlight reflections. Use very sharp Caribbean Sea with light pressure to create a medium wash in the rest. Apply both as smoothly as you can.

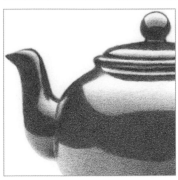

STEP THREE Use very sharp ultramarine with very light pressure on top of the powder blue in the highlight reflections. Use it with medium pressure in the rest. Keep the edges and borders very crisp.

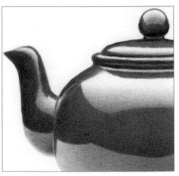

STEP FOUR Use very sharp indanthrone blue with medium-to-heavy pressure to model the forms in the dark areas—the undersides of the handle, lid, and spout, and the border of the pot. Also, use it to darken the lower part of the dark band around the center. Use more very sharp Caribbean Sea with light-to-medium pressure to smooth the highlight reflections, and sharp white with light pressure to smooth them to the brightest highlights. Finish with a colorless blender to completely smooth overall.

45 Shiny Gold

STEP ONE Shiny gold is surprisingly easy to draw, with just four colors. Begin with an outline and an overall medium wash of sharp canary yellow, reserving the bare paper for the brightest highlights.

STEP TWO Use very sharp yellowed orange with light pressure on top of most of the canary yellow, except where it is very bright near the highlights.

STEP THREE Use very sharp sunburst yellow with light pressure to create an intense transition zone between the previous two colors, particularly down the arm and next to the highlights. Also, layer it lightly across the upper chest.

STEP FOUR With very sharp burnt ochre and medium pressure, add the dark areas that give form to the sides of the arm, the side of the body, and under the chin, and fade them into the surrounding color with light pressure. Then, for final contrast, use sharp chocolate with medium pressure along the outside edge of the arm, in the armpit, and along the side. Use it with light pressure in the center of the burnt ochre areas on the chest and under the chin. If desired, smooth with a colorless blender.

Polished Silver

STEP ONE When polished, silver is almost as reflective as a mirror. This makes it surprisingly easy to draw with cool grays and blues, as long as you keep track of the reflections and highlights. Begin with a basic outline. Erase as much of it as you can and still see it, so the graphite lines won't show through the light colors to come.

STEP TWO First identify shapes that contain blue and fill them with a light layer of powder blue. Then identify shapes that are the lightest gray and fill them with a light layer of cool gray 10%.

STEP THREE Use very sharp blue slate with medium pressure on top of the powder blue on the left-side shapes, and very sharp periwinkle with light pressure on the right-side shapes. Identify the very darkest shapes and fill them with sharp cool gray 90% and medium pressure. Identify the next-to-lightest gray shapes and fill them with very sharp cool gray 30% and light pressure. Reserve the bare paper for the highlights.

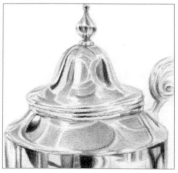

STEP FOUR Identify the next-to-darkest gray shapes and fill them with very sharp cool gray 70% and medium pressure. Now that all the basic shapes are filled, continue looking for more shapes and details and draw them with the appropriate blue or gray. Finish by cleaning up the edges of all the shapes and dabbing with poster putty to recover highlights as needed.

47 **Pewter**

STEP ONE Pewter is an alloy of tin and either copper or antimony, with a silvery color and dull, nonreflective shine. It's easy to portray with just four grays. Begin with a basic outline. Erase as much of it as you can and still see it, so the graphite lines won't show through the light colors to come.

STEP TWO With cool gray 10% and light pressure, create an overall light wash.

STEP THREE With cool gray 30% and light pressure, begin to model the round form of the cup by shading where it curves away at the edges, underneath the lip, and above the base. Use more coverage down the center where it is darkest.

STEP FOUR With cool gray 70% and light pressure, build contrast by shading around the curves of the cup, its base, and the underside of the handle, with more coverage down the center dark area. Create the final contrast with touches of cool gray 90% in the very center of the dark area and along the details of the handle. Finish by smoothing with a colorless blender.

Copper

STEP ONE Although colored pencils are available in metallic copper colors, they're of little use in creating a realistic copper texture. Five colors together work much better. Start with a basic outline of the pot and the major interior reflection areas. Erase as much of it as you can and still see it, so the graphite lines won't show through the light colors to come.

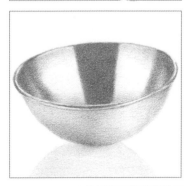

STEP TWO With sharp light peach and light pressure, create an overall light wash, with more coverage in the dark reflection areas and underside and less in the light reflection areas.

STEP THREE With sharp nectar and medium pressure, add the dark reflection in the center, allowing its edges to be a bit soft. Use it with lighter pressure to add the dark reflections at the sides, and note the slightly lighter areas in their centers. Also, use it with very light pressure to shape the inside and underside of the bowl. Then use it very sharp to add the rim.

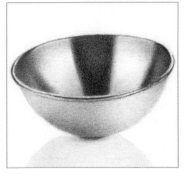

STEP FOUR Use sharp cadmium orange hue with medium pressure to brighten the center of the dark reflection in the center, and with light pressure in the dark reflections at the sides. Then use sharp Tuscan red with light pressure around the cadmium orange in those areas. The side reflections should be more orange. Use both colors very lightly on the inside and underside to achieve final contrast. With very sharp Tuscan red, define the rim. If necessary, smooth any roughness with a colorless blender.

49 # Hammered Brass

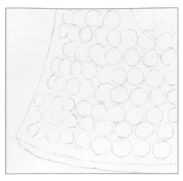

STEP ONE Brass is an alloy of copper and zinc that is a faded gold color with a slightly peach or orange undertone. Making hammered brass is a manual process, so the hammer marks aren't perfectly round or regular, and this makes it a forgiving texture to render. Begin with an outline of the hammer indentations. Erase as much of it as you can and still see it, so the graphite lines won't show through the light colors to come.

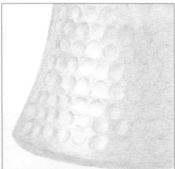

STEP TWO Use sharp cream with medium pressure to draw the shadowed parts of the highlighted indentations. Use sharp eggshell with light pressure everywhere else, and then use it with medium pressure to draw the shadowed parts of the indentations next to the highlighted ones. Note that the location of the shadow in the indentations varies a bit.

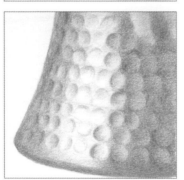

STEP THREE Use very sharp sand with light pressure to further define the shadowed part of the highlighted indentations. Use sharp beige sienna with light pressure to begin shaping the cup, creating more coverage around the indentations and less inside them.

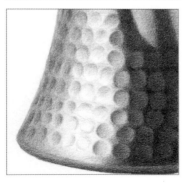

STEP FOUR Use very sharp pumpkin orange with very light pressure on top of the beige sienna to add warmth. Then use very sharp dark brown with medium pressure for contrast on the underside of the base and all over the dark side of the cup. Finally, use very sharp dark umber with light-to-medium pressure around the indentations on the dark side of the cup so that they're only slightly visible. Finish by enhancing the contrast of the edges of some of the indentations.

STEP ONE Terra cotta clay pottery has a dull finish that lends itself to a different technique for blending. Begin with a basic outline and a light wash of yellow ochre, with more coverage where the pot curves away from the light on the inside and outside.

STEP TWO Use sharp cadmium orange hue with light pressure on top of the yellow ochre, again with more coverage where the pot curves away from the light. Don't worry if the color is a little rough—the next step will take care of it.

STEP THREE Moisten a paintbrush or cotton swab with odorless mineral spirits and gently apply it overall to dissolve the wax binder away, staying within all the lines. This eliminates speckles of paper showing through. Don't worry about blotchiness—the next step will take care of that. Allow the mineral spirits to completely evaporate before proceeding, about 15-20 minutes.

STEP FOUR The dissolved wax residue on the paper will aid in blending from here on. Use cadmium orange hue and sharp peach with very light pressure to even out any blotchiness and clean up the edges. Add the dark interior and external shadows with very sharp terra cotta and light pressure. Add the dull highlights with sharp light peach and medium pressure. Finish by adding a shadow under the pots with sharp cool gray 10%, 50%, and 90%, placing the 90% closest to the pot.

51 Rusted Steel

STEP ONE Rust ranges in color from light orange to dark reddish-brown. It's easy to render its coarseness without drawing every speck. Start with a basic outline of the seams and rivets.

STEP TWO Apply layers of periwinkle and mineral orange that blend into each other with dull points, and don't worry about unevenness. Note that rust migrates downward, so there should be more orange toward the bottom.

STEP THREE Moisten a paintbrush or cotton swab with odorless mineral spirits and apply it overall to dissolve the wax away. This will ensure that subsequent darker colors don't blend into the light colors, but stay rough. This is the base color for the rust.

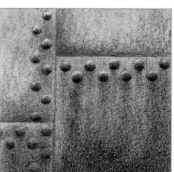

STEP FOUR With light pressure, hold the pencils on their sides and apply thin, sparse layers of cadmium orange hue and Tuscan red. Don't blend. Apply more along the joints and toward the bottom. Use the same two colors to draw the rivets, using Tuscan red with medium pressure for the side away from the light and cadmium orange hue with light pressure in the center.

52 Wet Pavement

STEP ONE The challenge of wet pavement is the patchy sheen and reflections on top of painted lines and cracks. The keys are to address these features separately, and to keep all strokes horizontal. Begin with an outline of just the painted lines and cracks.

STEP TWO Reserve the bare paper for the brightest reflections of the lighted street lamps until the last step. With sharp powder blue and light pressure, block in the areas of sheen. Then fill around those areas of sheen with sharp blue slate and light pressure, allowing a bit of overlap.

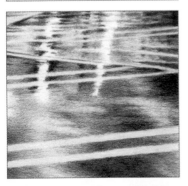

STEP THREE With sharp indanthrone blue and light pressure, deepen the contrast of some areas of the blue slate so that the areas of sheen begin to stand out. Also, use it to define the cracks and with medium pressure and tiny strokes to make the dark pole reflections in the distance; note that these are irregular and broken by the areas of sheen, which get slimmer and closer together in the distance. Finally, fill the pavement paint lines with sharp powder blue and medium pressure.

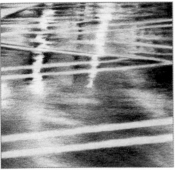

STEP FOUR Use very sharp indigo blue and heavy pressure to add final contrast to the darkest reflections. Smooth each area with a colorless blender. Finish by using sharp lemon yellow to add a few touches of color in the middle of the brightest streetlight reflections; avoid the edges to prevent a green blend.

53 Paint Drips

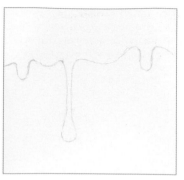

STEP ONE The viscosity of paint makes it run and drip differently than thinner liquids, like water. Gravity causes it to accumulate along a bottom edge until it's too heavy to hold together; as it drips, a thread follows with it. There are no straight lines, only curves. Begin this example with a basic outline of the edge of the paint.

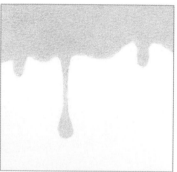

STEP TWO With sharp sunburst yellow and light pressure, create a very even, flat base layer of medium coverage. This will give brightness to the colors to come.

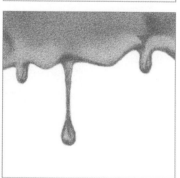

STEP THREE With very sharp orange and medium pressure, draw the crisp bottom edge of the paint and the shape of the drips. Then, with very light pressure and as smoothly as you can, create a gradation on top of the sunburst yellow, from medium coverage at the top to just a little at the bottom. This will make the bulge of the accumulated paint along the bottom edge appear.

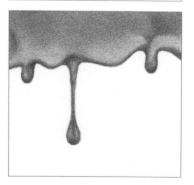

STEP FOUR With very sharp cadmium orange hue and medium pressure, reinforce the bottom edge of the paint and shapes of the drips. Use it with very light pressure to add a little more contrast to the gradation. Burnish with a colorless blender to finish.

54 **Brick**

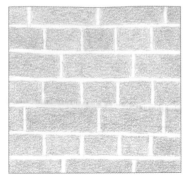

STEP ONE Old bricks are fun to draw because they are rough, imperfect, and uneven in color—and the colors vary from brick to brick. Begin with an outline of the brick pattern and a medium wash of peach on the individual bricks.

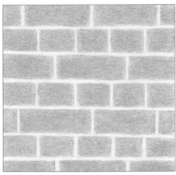

STEP TWO Moisten a paintbrush or cotton swab with odorless mineral spirits and gently apply it to the bricks to dissolve the wax away. This will eliminate speckles of paper showing through. Don't worry about blotchiness. Allow the mineral spirits to completely evaporate before proceeding, about 15-20 minutes. This is the base color for the bricks.

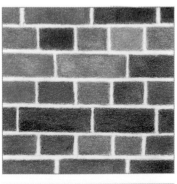

STEP THREE In this next step, apply all the colors with a dull point: nectar, henna, beige sienna, chestnut, and black raspberry. Experiment with layering any two of these colors, in either order, for a given brick. Allow them to be coarse, but keep the edges crisp. Use a colorless blender to smooth the bricks just a little.

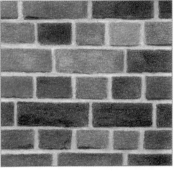

STEP FOUR Draw the mortar with dull French gray 20% and medium pressure, allowing it to be coarse. Finish by drawing the bottom edge of each brick with very sharp French gray 90%; make some of the edges and corners a little irregular to suggest that chips have broken off.

55 Peeling Paint

STEP ONE When paint peels, chunks of it blister and curl back, producing interesting shadows. Begin with a basic outline of the blisters and peels. Erase as much of it as you can and still see it, so the graphite lines won't show through the light colors to come.

STEP TWO For the first layer of color, use sharp light green with light pressure for an overall medium wash on the flat paint, sharp cloud blue with light pressure for an overall medium wash on the peels, and sharp cool gray 10% with medium pressure for the shadows of the peels that fall on the white wall beneath.

STEP THREE For the second layer, use very sharp peacock green with medium pressure to define the shadows under the peels that curl over the flat paint and the little blisters, sharp muted turquoise with medium pressure to shade the underside of the peels, and cool gray 90% with light pressure to define the fine line where some peels separate from the wall.

STEP FOUR For the third and final layer, use very sharp indigo blue with heavy pressure to deepen the contrast in the darkest curl shadows. Use it with light pressure to add contrast to the underside of the peels. Finally, use very sharp peacock green with very light pressure on top of all the light green; avoid the lighted side of the peels of paint that have separated from the wall but not curled, to give them a blistered look. If desired, smooth with a colorless blender.

Marble

STEP ONE Marble is characterized by translucence that allows underlying veins to show through, like pale skin. This makes it easy to draw, because blotchiness and jagged lines only add to the realism. Begin with an overall light wash of white to provide a waxy base for smooth blending of the light colors to follow. Then block in faint blurry areas with sharp grayed lavender and cloud blue, using light pressure.

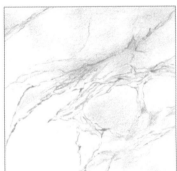

STEP TWO With very sharp beige and light-to-medium pressure, create the basic veins with jagged lines that cross each other in a few places. Darken some places in the cloud blue area with sharp periwinkle and light pressure.

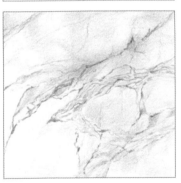

STEP THREE Continue adding thin, faint veins. Reinforce a few small segments of veins with very sharp beige sienna and light pressure. Also, add a few very faint veins with sharp lilac and very light pressure. Continue building the bluish and purplish values throughout, including between some of the veins.

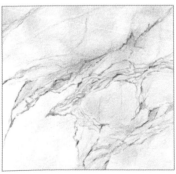

STEP FOUR With very sharp sepia and light pressure, reinforce some of the intersections of veins and indicate some veins that are at the surface. Although there isn't much pigment on the paper, finish with a colorless blender to smooth some of the bluish and purplish areas and some of the faintest veins—this adds to the translucent effect.

57 Pearl

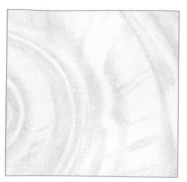

STEP ONE Much like marble, pearl has a translucent quality, but the surface gleams and is low contrast. Begin with an overall light wash of white to provide a waxy base for smooth blending of the light colors to follow. Then draw the basic curves and shadows with cool gray 10% and light pressure.

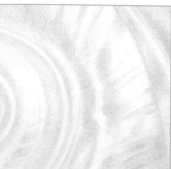

STEP TWO With sharp pink rose and light pressure, tint any areas that have even a hint of pink.

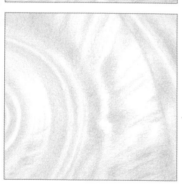

STEP THREE With sharp cloud blue and light pressure, tint any areas that have even a hint of blue. In some places, draw on top of the pink rose to build a purplish tint.

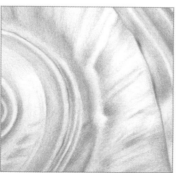

STEP FOUR With very sharp cool gray 50% and light pressure, draw the darkest creases; they don't need to be perfect, because pearl is an organic form. With sharp cool gray 30% and very light pressure, darken the shadow side of the undulations. Add a little more pink rose and cloud blue as needed to intensify the color of those shadows. Where there are several layers of color, finish by smoothing with a colorless blender; where there are only a couple of layers, finish by blending with sharp white and light pressure.

58 Amethyst

STEP ONE The keys to successfully drawing any cut gemstone are to keep the pencil points very sharp, which requires frequent sharpening, and to keep the edges very crisp. Begin with an outline of all the facets and refractions of facets that you can see.

STEP TWO For this amethyst, we will use only purples and white. First identify the pure white highlight facets, and fill them with white to preserve them. Then identify the very darkest facets, and fill them with dioxazine purple hue and medium pressure. Fill the top facet with a medium wash of lilac. Look for some other facets that are close to the same value and color, and fill them as well.

STEP THREE There are likely a couple of other distinct colors in the facets, so identify them and fill them with dahlia purple and imperial violet. Smooth facets with a colorless blender as you go.

STEP FOUR Continue filling facets with the four purples and light-to-medium pressure. Some facets are indistinct. Some facets transition between two colors. Some need a bit of white for a lighter tint. If you get lost, don't worry—a couple of small errors will not be noticeable. Finish by sharpening any edges that became soft during blending.

59 Smooth Wood

STEP ONE Smooth varnished or stained wood has a warmth and richness that shows off the wood grain. Make all pencil strokes in the direction of the wood grain. For this example of pine, begin with an overall medium wash of sand. Then use sharp burnt ochre and light pressure to suggest the areas where the wood is darker.

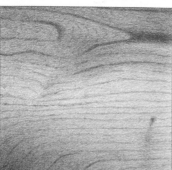

STEP TWO Use sharp goldenrod with light pressure on top of the burnt ochre to add warmth. With very sharp chocolate and light pressure, draw the grain lines. Don't worry about detail yet.

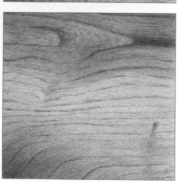

STEP THREE Moisten a paintbrush or cotton swab with odorless mineral spirits, and gently apply it overall in the direction of the wood grain to dissolve the wax binder. This will eliminate speckles of paper showing through and intensify the colors. Allow the mineral spirits to completely evaporate before proceeding, approximately 15-20 minutes.

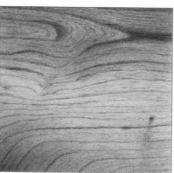

STEP FOUR To finish, use very sharp burnt ochre and chocolate with light pressure to reinforce some of the wood grain lines, and with very light pressure to add some fainter grain lines.

60 Aged Wood

STEP ONE Old, dry, fading, cracked wood that has been exposed to the outdoors is fun to draw because it rewards rough, heavy-handed treatment. Where it is especially dry and cracked, it's very rough; where newer wood is exposed, it's a bit smoother. For this example, begin with somewhat dull mineral orange and medium pressure to plan the areas of the knots and newer wood. Bring some streaks into the old wood area.

STEP TWO Use somewhat dull French gray 30% and medium pressure to fill the areas of the old wood. Overlap into the mineral orange a little, and bring some streaks into the new wood area; they will be hard to see.

STEP THREE With sharp French gray 70% and medium pressure, add long, uneven, jagged lines in the direction of the wood grain in the old wood area. Do the same with Tuscan red in the newer wood area, and start to indicate streaks and the inside perimeter of the knots.

STEP FOUR Use a colorless blender to somewhat smooth the newer wood. Then, with very sharp dark umber and heavy pressure, create large cracks and nail holes throughout. Keep the pencil very sharp and use medium pressure to make tapered strokes for the lesser cracks, including the cracks in the knots and grain lines throughout. Flow lines and cracks around the knots. With very sharp Tuscan red and heavy pressure, draw some grain lines in the newer wood. Finish by adding a few strokes of both Tuscan red and mineral orange with medium pressure in the old wood to suggest that it's splintering off, and make a few little marks across the grain with dark umber.

61 Wooden Barrel

STEP ONE Barrels are most commonly made of oak, held together by steel hoops. For this example of a relatively new barrel, begin with a basic outline.

STEP TWO Use sharp sand and light pressure to create an overall medium wash for the oak. Use warm gray 10% and light pressure for the hoops and shadow, with more coverage where they are less reflective.

STEP THREE Use very sharp mineral orange with light pressure to draw many fine lines of varying length and thickness, representing the staves' wood grain. They don't need to exactly match your reference. Use medium pressure to begin defining the bold grain pattern on the lid, and create contrast under the top of the rim. Keep the edges of the hoops crisp. Use sharp warm gray 30% with light pressure to enhance the dark areas of the hoops and the shadow.

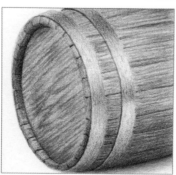

STEP FOUR Add more fine wood grain lines in the staves with very sharp terra cotta and light pressure, closer together and heavier where the barrel curves under. Use medium pressure under the top of the rim and to enhance the bold grain pattern on the lid. Use very sharp warm gray 70% with light pressure, stroking in the direction of the hoops, to give final contrast to the dark areas. Allow it to look a little rough, representing low-grade steel. Deepen the shadow closest to the barrel. Finish with very sharp warm gray 90% and light pressure to draw the front edges of the hoops and the stave edges; note that the hoop edges are more pronounced where they curve away, and the stave edges are more pronounced where they directly face the viewer.

Wrought Iron

STEP ONE Although you might think of wrought iron as black, it often has a dark, bluish-gray patina, which we will produce in this example with just three colors. Begin with a basic outline.

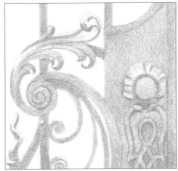

STEP TWO For the first layer, use sharp cool gray 30% and light-to-medium pressure to create a monochromatic drawing with more coverage in shadow areas. Keep the edges crisp.

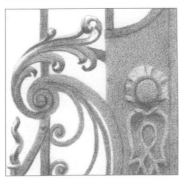

STEP THREE Repeat the previous step with sharp slate gray and light-to-medium pressure on top of the cool gray 30%.

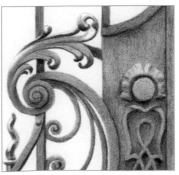

STEP FOUR Repeat again with very sharp cool gray 90% and light-to-medium pressure on top of the slate gray. Allow the coverage to be a little uneven, as this adds to the realism of the patina. Then use the sharp cool gray 90% with heavy pressure to draw the darkest lines and shadows. Finish by smoothing somewhat with a colorless blender; allow a little roughness to remain for the patina.

FOOD & BEVERAGE

Red Wine

STEP ONE The challenge of red wine is that it is transparent in a small quantity, but darkly opaque in a large quantity. The key is to layer the colors so that the red shows through from underneath. Begin with a basic outline.

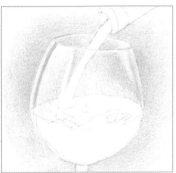

STEP TWO Clear glass is almost invisible without something dark behind it, so use sharp cool gray 20% and light pressure to create the background, reserving the bare paper for the brightest highlight on the side and around the rim.

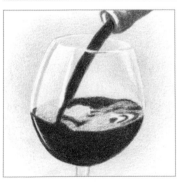

STEP THREE Use sharp crimson lake with medium pressure to create an even, medium-heavy layer for the pour stream and the wine below the surface. Use it with light pressure for the surface foam. Reserve the bare paper for the bright reflections on the surface. Use sharp dark green to block in the bottle, reserving the bare paper on the lip for the next step.

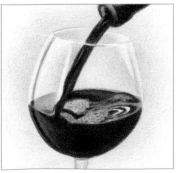

STEP FOUR Use very sharp black with heavy pressure for a few strokes in the pour stream and the dark highlight below the surface near the left side. Also, use it to darken the wine below the surface, allowing red to show through on either side of the center and along the right edge. Use it in the same manner on top of the green on the bottle. Use pink rose with medium pressure to darken some of the surface foam, and for the light highlight below the surface near the left side. Dot some crimson lake in the surface foam to suggest bubbles. Use sharp kelp green with light pressure for the lip of the bottle. Finish by brightening some of the pour stream and some small areas of the surface with touches of permanent red.

64 Citrus Fruit Rind

STEP ONE The dimpled skin of any citrus fruit, such as oranges and lemons, is surprisingly easy to render without drawing each individual dimple. For this example of an orange peel, begin with a basic outline. Erase as much of it as you can and still see it, so the graphite lines won't show through the light colors to come.

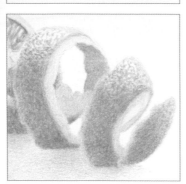

STEP TWO For the first layer of color, use sharp sunburst yellow and light pressure for an overall light wash on the exposed cuts, and a medium wash on the surface, reserving the bare paper for the highlights. Then use the point of the pencil to make dots in the highlights—darker where the light is strongest. The dots don't need to be perfect.

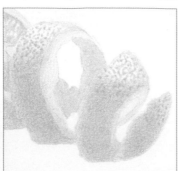

STEP THREE Where the underside of the cut rind is visible, darken it with sharp goldenrod and light pressure. Use sharp yellowed orange and light pressure with small, overlapping, circular strokes on top of the sunburst yellow on the surface, and add a few more dots at the edges of the highlights.

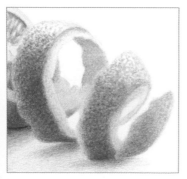

STEP FOUR Use sharp cadmium orange hue and medium pressure with small, overlapping, circular strokes on top of the yellowed orange on the lower half of the rind curls for final contrast. Use heavier pressure at the bottom edges. Add some dots in the middle of the curls. Finish by using sunburst yellow to make some dots along the area where the exposed cuts meet the surface.

Cut Citrus Fruit

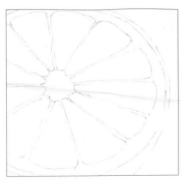

STEP ONE The segments inside any citrus fruit, such as grapefruit, are packed with little sacs of juice that, like the segments, radiate out from the center. So, all strokes should also radiate from the center. Begin with a basic outline of the segments. Erase as much of it as you can and still see it, so the graphite lines won't show through the light colors to come.

STEP TWO With sharp lemon yellow and medium pressure, create short and long strokes out from the center, reserving the bare paper for highlights. They don't need to exactly match your reference. Also, use lemon yellow for the skin and around the outside edge of the rim cut.

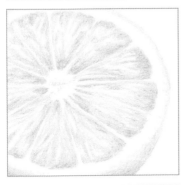

STEP THREE Identify some of the darkest striations in the juice sacs, and use sharp yellow ochre with light pressure to enhance their contrast. Because the sacs bulge upward a bit, create slightly more coverage near all the borders of each segment to create dimension. Also, use yellow ochre to shade the skin and draw the edge of the rim cut.

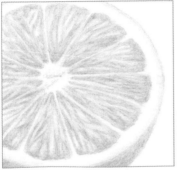

STEP FOUR Continue adding lemon yellow striations, with yellow ochre strokes on top of them that don't completely overlap, until you are happy with the contrast. Be sure to reserve bare paper as highlights for a few striations. Smooth with a colorless blender, if desired.

66 Pineapple

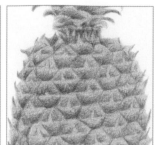

STEP ONE The surface of a pineapple is a complex structure of hexagonal segments, each with an upward flap that has a center spine. Ripe segments tend to be greenish on the lower half and orangey on the upper half. Begin with a basic outline.

STEP TWO With sharp yellow ochre and light pressure, create an overall medium wash on the pineapple body. Use sharp celadon green with light pressure to block in the leaves.

STEP THREE With sharp green ochre and light pressure, fade the lower half of each segment and, more lightly, the upper halves from the flap upward. Also, use it as a light second layer on the leaves.

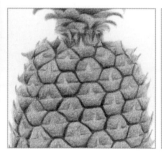

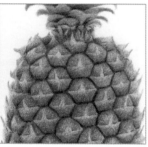

STEP FOUR With sharp Spanish orange and light pressure, fade the upper half of each segment, and the lower halves from the flap downward. With sharp dark umber and medium-to-heavy pressure, draw the gaps between the segments. Don't worry about making perfect hexagons—each segment is different and unevenly shaped. Use the same pencil very sharp with very light pressure to enhance the edges of the flaps and spines and to draw the darkest shadows under the leaves.

STEP FIVE Use sharp burnt ochre and light-to-medium pressure to add a reddish blush to the top half of each segment, heavier at the edges, and with very light pressure as a wash on the lower halves. Add a little more green ochre to the lower half of each segment. Finish by smoothing the leaves and any excessive roughness with a colorless blender.

67 Apple

STEP ONE Apples are surprisingly easy to draw by taking a short detour through some unexpected colors, which help produce a more accurate final color and texture. Begin with a basic outline. Erase as much of the highlight outlines as you can and still see them, so the graphite lines won't show through later.

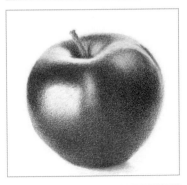

STEP TWO Where the skin is yellow, use sharp jasmine with light pressure to generally block in those areas. Where it is very dark red, due to shadow, use sharp dark green with light pressure to create an underpainting. Where it is very light red around curves, use sharp pink rose with light pressure to create an underpainting. Where there are strong highlights, such as around the top and on the side, use sharp white with medium pressure to preserve them and provide a waxy layer for smooth blending later. Fill the stem with sharp burnt ochre and medium pressure.

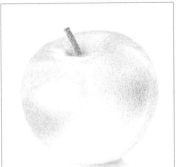

STEP THREE Use sharp scarlet lake with a full range of pressure everywhere the skin is red—heavy pressure on top of the dark green, light pressure on top of the pink rose, and very light pressure on top of the jasmine and next to the white. Fill the tooth of the paper as smoothly as you can. Notice how the dark green underpainting produces a convincing shadowed red!

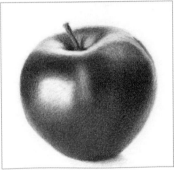

STEP FOUR Use sharp scarlet lake with medium pressure to further shade the contours near the darkest areas, and to add the shadow on the stem. Finish by smoothing all over with a colorless blender.

68 Grapes

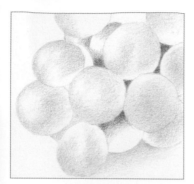

STEP ONE The challenge of grapes is their translucent glow combined with a waxy coating. The keys to drawing them are to keep your pencils very sharp, and use light pressure to make very small, overlapping, circular strokes. Begin with a basic outline and a light wash of white to provide a waxy base for smooth blending of the light colors to follow. In the darkest recesses, apply a light wash of dark green, and wherever you see waxiness, apply a light wash of pink rose.

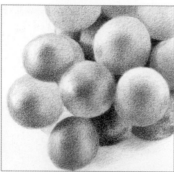

STEP TWO On top of the dark green in the darkest recesses, apply raspberry. Use magenta to carefully model the grapes with more coverage in the centers, where they are most intensely colored, and where they touch neighboring grapes.

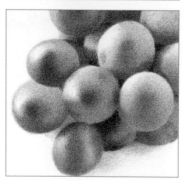

STEP THREE On the darkest grapes in shadow, apply grayed lavender with medium pressure. Also, apply it with light pressure wherever you see waxiness. Reserve the bare paper for the brightest highlights. Apply permanent red on top of the most intense areas of magenta to begin producing the glow.

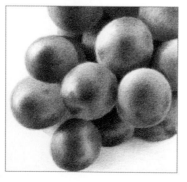

STEP FOUR For final contrast, apply a small amount of raspberry on top of the permanent red in the centers of the grapes and where they touch neighboring grapes. Use it to make a few splotches to represent where the waxiness is worn away. Finish by sharpening any blurry edges and smoothing with a colorless blender.

Strawberry

STEP ONE The key to success in rendering a ripe red strawberry is to simply not let the seeds scare you. Begin with a basic outline that includes the location of each seed.

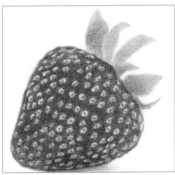

STEP TWO With very sharp yellow ochre and heavy pressure, draw a dot for each seed. With sharp permanent red and medium pressure, draw a circle around each seed and fill the gaps between the circles. Use heavier pressure at the bottom where it meets the table. Block in the basic leaves, with sharp dark green and sharp limepeel.

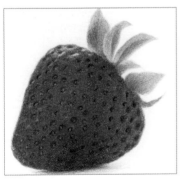

STEP THREE With very sharp dark green and medium pressure, fill each circle around the seeds; for those near the bottom where the berry meets the table, darken the seeds as well. Use sharp crimson red and heavy pressure to fully darken the berry and add dimples next to the seeds near the top and bottom. Finish the leaf details with very sharp dark green and light pressure; they should be darkest where they meet the berry.

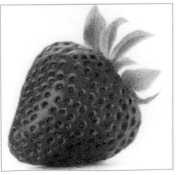

STEP FOUR Spray the drawing with workable fixative and let dry. This will enable you to add soft highlights on top of the heavy red pigment. With very sharp white and heavy pressure, draw little curves around the seeds that are not in shadow, as well as in a stripe down the center around the seeds there. The seeds should appear recessed; if they don't, use crimson red again to restore a gap between the seed and the highlight. (Note: For an even whiter highlight, you can use the moist point of a white watercolor pencil.)

70 Coconut

STEP ONE The very fibrous shell of a coconut is easy to draw, because it's so coarse that the fibers almost suggest themselves. Begin with a very simple outline.

STEP TWO With sharp burnt ochre and medium pressure, make long strokes that follow the contour of the coconut. In the center third, press harder to make darker lines to suggest fraying fibers. Make a few short, tapered strokes around the perimeter as well to suggest fraying fibers.

STEP THREE Use the lines from the previous step and a bit of imagination to "see" more and more frayed ends and fibers, and enhance them by using very sharp Tuscan red and chocolate with medium-to-heavy pressure to darken the spaces between and underneath them. They don't need to match your reference.

STEP FOUR Use a colorless blender to smooth most of the fibers somewhat to enhance the color without flattening the texture completely. Finally, use very sharp dark umber and medium-to-heavy pressure to increase the contrast even more between and underneath many of the fibers you created in the previous step.

Peach

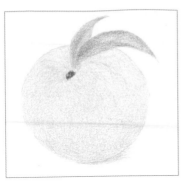

STEP ONE Peaches are known for blushing color with soft transitions. Begin with a basic outline. Erase as much of it as you can and still see it, so the graphite lines won't show through the light colors to come. Use sharp eggshell to create an overall light base layer on the peach, sharp limepeel for the leaves, and sharp sandbar brown for the stem.

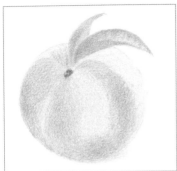

STEP TWO Where the peach skin is yellowish, apply sharp Spanish orange with light pressure, following the contours, and fade it out into the areas that will be reddish. Create more coverage in the more intensely yellow areas. Use sharp spring green as the second layer on the leaves.

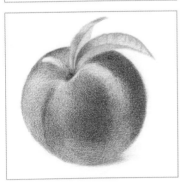

STEP THREE Where the peach skin is reddish, apply very sharp carmine red with light pressure as smoothly as you can, following the contours. Create more coverage in the darker areas, and fade it out into the areas that are yellowish. Allow some streaks and little blotches, which adds to the realism. With sharp dark green and light pressure, add final contrast to the leaves and a shadow on the peach under them. Also, add a few touches on the stem to increase its contrast.

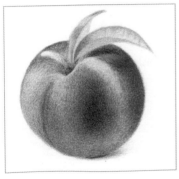

STEP FOUR Where the reddish areas are darkest, apply very sharp pomegranate with medium pressure, as smoothly as you can. Also, apply it on top of the dark green in the shadow under the leaves and on the stem for final contrast. Use sharp cool gray 20% with medium pressure to add a little patch of fuzzy appearance on the shoulder next to the leaf shadow. Finish by smoothing completely with a colorless blender.

72 Walnut Shell

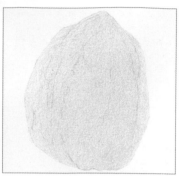

STEP ONE Walnut shells, like the nutmeat inside, are known for their undulating form, each one unique. For this example, begin with a basic outline and an overall medium wash of eggshell, applying lighter coverage on the lighted side.

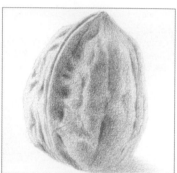

STEP TWO With sharp light umber and light pressure, block in the basics of the undulating shapes and creases. They don't need to exactly match your reference.

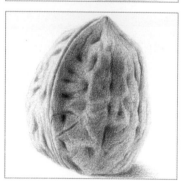

STEP THREE Add warmth and contrast to the shadowed undulating shapes with sharp burnt ochre and light-to-medium pressure, with more coverage in the richest-colored areas. Use very sharp dark brown with medium pressure to define the darkest creases and dimples.

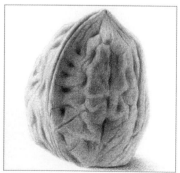

STEP FOUR Use sharp yellow ochre and light pressure over-all, and then smooth with a colorless blender, being careful not to blur the shapes and creases. With very sharp dark brown and light-to-very-light pressure, draw the finest creases and enhance the contrast around the undulations.

73 Black Coffee

STEP ONE The key to successfully drawing black coffee is to not use black! Coffee is a very rich, dark brown, while black pigment is flat and dull. Begin with a basic outline of the cup, coffee, bubble rim, and reflection.

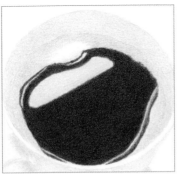

STEP TWO For the first layer, use sharp cool gray 10% and medium pressure for the cup, sharp beige and light pressure for the bubble rim, sharp chocolate and medium pressure for the coffee, and sharp warm gray 10% and light pressure for the big reflection. Reserve the bare paper for the strongest highlights on the rim of the cup and a band next to the bubble rim.

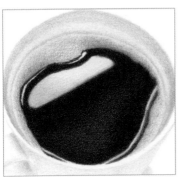

STEP THREE Use sharp cool gray 30% and light pressure to draw a line where the bubble rim meets the cup, and to darken the inside of the cup. With sharp beige sienna and light pressure, darken the bubble rim where it meets the coffee. Use sharp dark umber and heavy pressure on top of the chocolate, allowing some of the chocolate to show through in the center. Use sharp French gray 20% and light pressure to slightly darken half of the big reflection and blur its boundary on the flat side.

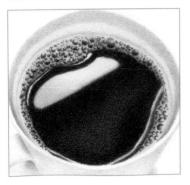

STEP FOUR With cool gray 50% and light pressure, create final contrast around the inside and outside of the cup. Finally, use very sharp dark umber and light-to-medium pressure to create the bubbles—crescents of various sizes, with dots filling some of the spaces between. Note that there are no visible bubbles at the boundary with the cup.

74 **French Baguette**

STEP ONE Bread can seem daunting because of the air pockets and holes. But you don't need to draw every single hole, or follow your reference exactly, to render French bread. Begin with a light outline and an overall light wash of cream on the bread and putty beige for the shadow.

STEP TWO Use sharp yellow ochre and light pressure to block in the major holes and give shape to the loaf. Create more coverage where the crust is more toasted and where the holes are deepest. For the shadow, add a light layer of chocolate, with more coverage closest to the loaf. Also, use it to draw the gap between the loaf halves.

STEP THREE Use sharp mineral orange with light pressure to create a more toasted look on the crust, especially in the torn edges and seam down the middle. Use sharp light umber with very light pressure to increase the contrast inside the major holes on the top loaf half, and add some semi-random squiggles to suggest smaller holes. Use it with light-to-medium pressure on top of the yellow ochre on the end of the lower loaf half to darken and increase the contrast of the torn pieces and holes.

STEP FOUR Use very sharp burnt ochre and medium pressure to enhance the jagged, toasted seam and the bottom edge of the top loaf half. Use it with light pressure to make the crust more golden-toasted in a few places. Allow the look to be a little rough, which adds to the realism. Add more yellow ochre and light umber as needed until you're happy with the contrast and color of the holes and crust. Finish by drawing the darkest shadow line under and between the loaf halves with sharp dark umber and medium pressure.

Frosting

STEP ONE Cake frosting is made with either powdered sugar or cream cheese and is tinted with food coloring. It is low contrast and, where folds face each other, the color is multiplied. These steps would also work for drawing ice cream. Begin with a basic outline. Erase as much of it as you can and still see it, so the graphite lines won't show through the light colors to come. Apply an overall light wash of white to provide a waxy base for smooth blending of the light colors to follow.

STEP TWO Use sharp hot pink and very light pressure to model the forms of the swirls, with more coverage in the dark creases. For the cupcake, use sharp chocolate and medium pressure.

STEP THREE Use sharp pink and light pressure on top of the hot pink to alter its color and increase the contrast in the darkest creases. For the cupcake, use sharp burnt ochre and medium pressure on the lit side. Keep the edges crisp.

STEP FOUR Use very sharp permanent red and light pressure to add final contrast in the darkest creases. Use a colorless blender to smooth any roughness where there is more pigment, and use sharp white to smooth where there is almost no pigment. On the cupcake, use sharp dark umber with heavy pressure on the unlit side and directly under the frosting, and use somewhat dull white with medium pressure on the lit side. Then make several small marks with the dark umber on top of the white to suggest the spongy cake surface.

76 Dark Chocolate

STEP ONE The keys to drawing convincing dark chocolate are to not use black and to save heavy pressure for later steps. Dark chocolate is a very rich, dark brown, while black pigment is flat and dull. Applying heavy pressure too early would prevent the addition of more color on top. Begin with an outline of the chocolate pieces.

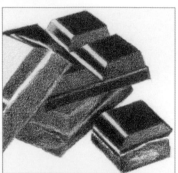

STEP TWO Preserve the almost-white highlights with very sharp French gray 10% and light pressure. Then use sharp chocolate with medium pressure on the top faces; they really are that color and will not change much. Use it with light pressure on the front faces, where more colors will be added to darken. Keep the edges very crisp.

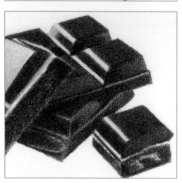

STEP THREE On the front faces, which received only a light layer of chocolate in the previous step, add sharp dark brown with light-to-medium pressure, applying more coverage where the candy is in shadow. Also, draw sharp lines with heavy pressure where segment faces meet.

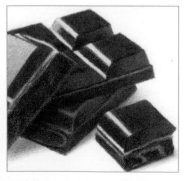

STEP FOUR Where there are breaks, use very sharp beige and very sharp burnt ochre together to draw the light color of the crumbs. Use sharp French gray 50% with light pressure to suggest soft reflection of ambient light on the front faces; if it's too gray, lightly add another layer of dark brown on top. For final contrast, use sharp dark umber with heavy pressure in the darkest shadow areas. Finish by smoothing with a colorless blender and cleaning up the edges.

NATURE

77 Smooth Bark

STEP ONE Sycamore bark is interesting because it is smooth, yet has subtle, irregular color shapes—like a jigsaw puzzle. Begin with a light outline. The shapes don't need to be exact, because nature isn't exact.

STEP TWO Cover the entire area with a light wash of cream. This provides a slightly warm color base and a layer of waxiness to smooth the following layers. Indicate the darker patches with a light layer of 20% French gray. Add some touches in the surrounding areas to create texture, since the trunk surface isn't perfectly smooth.

STEP THREE The darker patches should have a cooler tone than the surrounding areas, so add a bit of slate gray, as well as light touches in the surrounding areas. Use this color to begin defining the knots. With a very sharp point and very light pressure, draw the bottom edges of some of the patches.

STEP FOUR To finish, use black grape to lightly reinforce some of the areas and edges on which you used slate gray. This will produce a shallow 3-D effect, just like real bark.

Rough Bark

STEP ONE Pine bark is very rough, with deep, uneven grooves and subtle color all over. Begin with a basic outline of the deep grooves.

STEP TWO This is one of the few occasions when it works best to use the side of the colored pencil instead of the point. Cover the whole area with a light and very uneven layer of cool gray 20%. Allow a few spots to remain white—these will be the bark highlights.

STEP THREE Use cool gray 70% on its side with light pressure to roughly define the deep grooves. Use a tiny scribbling motion with medium pressure to darken some of the lighter gray areas. With a dull light umber point, add dabs of color everywhere except on the highlight spots you previously reserved. These dabs represent flecks of bark that have fallen off, revealing the fresher bark beneath.

STEP FOUR Use a tiny scribbling motion and medium pressure with black raspberry to create some color inside the grooves. Add dabs and scribbles in the same areas where you previously dabbed light umber. To finish, use a very sharp black pencil with heavy pressure to sharply define the fine cracks and the deepest recesses in the grooves. With medium pressure and a scribbling motion, darken the insides of the grooves next to the sharp lines to give the grooves final depth.

79 Pine Needles

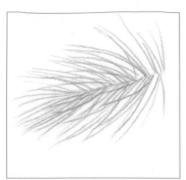

STEP ONE Since pine needles are as thin as pencil points, don't start with an outline. Instead, begin directly with color. Use limepeel with a very sharp point to make quick outward strokes from the imaginary stem. Let the strokes overlap, and make some further apart than others and some shorter than others.

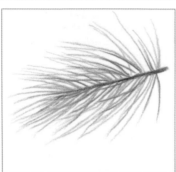

STEP TWO Repeat step one with a few strokes, using very sharp sap green light. Retrace some needles with very sharp olive green on the sections nearest the stem to add dimension. Draw the stem with green ochre, making it thicker at the base and fading into the needles where they overlap its tip.

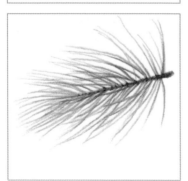

STEP THREE Each needle attaches to the stem, and the stem is rough. Use very sharp black raspberry to mark some of these attachment points, and make some marks on the stem. Enhance a few needles, as some are in various stages of growth.

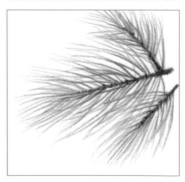

STEP FOUR Repeat these steps to create more pine needles as desired. Note that some species have long needles and some have short needles; some have dark green needles and some have light green, or even bluish needles; some have thick needles and some have thin needles—know your tree before you draw!

Pinecone

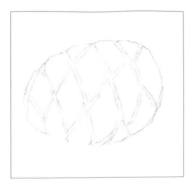

STEP ONE Cones vary between species of pines and evergreens, from compact forms the size of a ping-pong ball to elongated forms the size of a football. The largest of all trees, the giant sequoia, produces the smallest cone, which is demonstrated here. Start with a basic outline of the shape and segments.

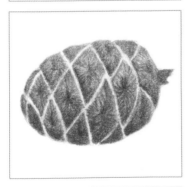

STEP TWO With a sharp point and light pressure, apply a layer of sandbar brown, darker in the centers and around the edges of the segments, and even darker along the bottom of the cone. Don't worry about staying within the bounds of the segments.

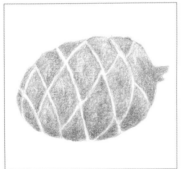

STEP THREE With a sharp point and medium pressure, apply a layer of sienna brown, darker in the centers and around the edges of the segments, and even darker along the bottom of the cone. Radiate the strokes outward from the centers and inward from the edges of the "faces" to create highlights.

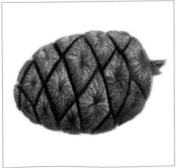

STEP FOUR With a sharp point and medium pressure, add radiating strokes of black grape and dark cherry to further develop the wrinkled faces of the segments. Add a few light strokes of black to enhance the centers and darken the bottom segments. Finish by using black and heavy pressure to fill the gaps between the segments, stopping short of the cone's perimeter.

81 Palm Frond

STEP ONE There are many types of palms, varying in shape, size, fruit, trunk texture, and leaf structure. The leaves of this particular palm have thin ribs and are offset from each other down a thin, strong stalk. They attach at a tiny point, flare, and then taper to a graceful, sharp tip. It's important to keep your pencils very sharp to convey these crisp lines. Since the colors are light, lightly draw the basic outlines with very sharp limepeel rather than graphite. If the outlines aren't crisp, don't worry—we'll make them crisper as we continue.

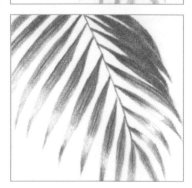

STEP TWO With a sharp point and light pressure, fill in the outlines with limepeel. Leave highlights blank or stroke even more lightly. Stroke in the same direction as the leaf growth.

STEP THREE With a sharp point and light pressure, use marine green to darken the tips and part of the bodies of the leaves. Then, with a very sharp point and medium pressure, draw the stalk, the leaf attachments, and some of the ribs. Clean up the leaf edges.

STEP FOUR To finish, use a very sharp point and medium pressure with black grape to enhance the stalk, the attachments, some of the ribs, and the base of the darkest leaves. If there is any roughness in the highlights, go over them with white to smooth.

82 Thatched Roof

STEP ONE A thatched roof is made of palm fronds or bunches of grass, attached in vertical, overlapping layers. All your strokes for these steps should be vertical, following the direction of the grasses. Begin with a light layer of cream, applied in uneven vertical strokes. The unevenness will help produce highlights later.

STEP TWO Use beige to define the edges of the thatch layers with quick strokes that begin heavy at the top and fade to light. Vary your pressure and allow the strokes to overlap. Make some heavier, shorter strokes closest to the edge as needed.

STEP THREE Further define the edges of the thatch layers, in the same manner as step two with light umber. Make some strokes from the edges upward to start defining the tips of the grass.

STEP FOUR With a very sharp point, use burnt ochre to add very fine strokes to multiply the blades of grass. Add a few heavy, short strokes both upward and downward from the edges of the thatch layers. To finish, use chocolate with light pressure to suggest even more blades of grass. Use medium pressure in short upward and downward strokes from the edges of the thatch layers to deepen the shadows.

83 Fern

STEP ONE There are many types of ferns, varying in shape, size, growth pattern, and color. The leaves of this particular fern grow downward, and both the leaves and their lobes are symmetrical, tapering to very slim points. Begin with a light outline.

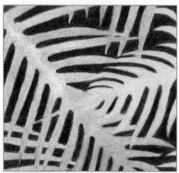

STEP TWO The frontmost leaf is closest, so it is lighter and brighter. Use very sharp chartreuse with light pressure to fill it in. Use very sharp limepeel with light pressure to fill in the other leaves. Fill in the gaps with black, using medium pressure. Try to keep the edges sharp, but don't obsess—we will refine them as we go.

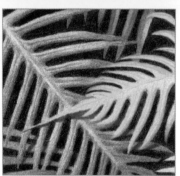

STEP THREE With sharp Prussian green, darken the lower edges of the lobes, draw the ribs, and, with heavy pressure, create the shadows of the overlapping lobes. Add a light layer of yellow chartreuse to the frontmost leaf to brighten it further, and use sharp sap green light with medium pressure to darken the trailing edges of its lobes and draw the ribs.

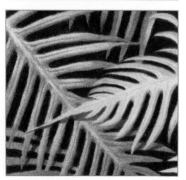

STEP FOUR Go over the lightest areas of the back leaves with very sharp yellow chartreuse and the darker areas with very sharp chartreuse to enhance the colors. Use a sharp colorless blender to further smooth. Finish by adding a second layer of black to the background with heavy pressure to add depth. With a very sharp point, refine all edges.

Moss

STEP ONE There are many kinds of moss, varying from barely visible to long and stringy, and in a surprising range of colors. This particular moss is often found on trees in damp woods and has a blobby form, brilliant color, and soft, fuzzy texture. Start by roughing in the tree bark around the moss with the side of a cool gray 20% pencil.

STEP TWO Make the bark appear rougher with the side of a cool gray 50% pencil, and indicate cracks in it with heavy, jagged strokes of black. Fill the moss areas with an even layer of chartreuse. Indicate areas where the moss has browned with an overlay of sienna brown.

STEP THREE Create blobby forms in the moss with very sharp limepeel, followed by very sharp Prussian green, using light pressure and a scumbling stroke to keep the look soft. Use heavier pressure in the darkest areas.

STEP FOUR Go over all the moss with another layer of chartreuse and medium pressure to punch up its brightness and blend the previous layers together. This is a more effective technique for producing a soft look than simply starting with a heavier layer of chartreuse. Finish with very sharp sepia and medium pressure to enhance the darkest recesses under and around the blobs of moss and create more contrast in the bark. Use light pressure to make a few tiny strokes to suggest the fuzziness of the moss.

85 Grass Field

STEP ONE There are three keys to achieving a lovely grass field: (1) keep all the strokes vertical, regardless of how far into the distance the field extends; (2) use a variety of colors; and (3) make many subtle tufts, rather than flat color. These keys are true whether you are drawing a wild meadow or a manicured lawn. To begin this field of tall grasses, block in the sky with a light wash of sky blue light, the trees with limepeel, the grass with yellow chartreuse, and the path with French gray 20%.

STEP TWO Use medium pressure with Prussian green to indicate the dark shapes in the trees. Use very sharp limepeel with light pressure to indicate the darkest areas of the grasses. Use sharp sandbar brown and medium pressure to darken the path.

STEP THREE Instead of using a darker green to further darken the trees, create much better contrast and color with heavy pressure and black cherry. Then sharpen the pencil and draw a few strokes in the darkest clumps of grasses; stroke upward from the bases of the clumps. Add a light layer along the edge of the path. Draw clumps of short, light, upward strokes of indigo, spring green, chartreuse, and limepeel throughout the field, all with very sharp points.

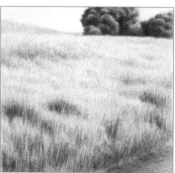

STEP FOUR With very sharp Prussian green, enhance the clumps further and repeat any of the other colors used in step three as needed. To finish, you may wish to use the sharp tip of a craft knife to scratch out some lines in the dark clumps to bring back the look of light blades of grass. Use a colorless blender with heavy pressure to smooth any rough spots.

Flower Petals

STEP ONE All flower petals grow outward from a base, so all your pencil strokes should follow that direction. For this fiery red-orange tulip, finishing the background first ensures that the value range is correct in the blossom. First lightly draw the blossom outline. Then fill the background with dark green, using heavy pressure so there are no specks showing through, while keeping the edges crisp. Lightly spray a layer of workable fixative over your work to prevent the dark color from polluting the blossom in the following steps. Fill the blossom with a light wash of sharp lemon yellow.

STEP TWO Go over almost all the lemon yellow with a wash of a sharp Spanish orange. The two washes together provide a waxy base for a smooth blend of the darker colors to come.

STEP THREE Go over almost all the Spanish orange with a wash of very sharp pale vermilion. Then use medium pressure to indicate the darker parts of the petals, which will begin to give them form. Notice that the blend is becoming smooth.

STEP FOUR Go over almost all the pale vermilion with a wash of very sharp crimson lake. Use heavier pressure in the center of the blossom and at the innermost edges of the petals to create depth, as well as around the center of the bottom petal to give it richness. Draw some light strokes with very sharp crimson lake and pale vermilion to suggest the subtle ridges in the petals. Tighten up any edges that have become fuzzy. Finish by using a colorless blender with light pressure to further smooth the blend.

87 Mountain Rock

STEP ONE Mountain rocks are typically very rough, irregular, and jagged, which makes them surprisingly easy to render without stressing over exacting details. Use dull cool gray 20% on its side to create an overall rough look.

STEP TWO Use dull slate gray and sandbar brown to block in some angular shapes, varying the pressure from light to medium.

STEP THREE Now give the rocks form and dimension. With very sharp indigo blue and heavy pressure, define the darkest cracks and gaps between blocks of rock. With medium pressure, create some shadows under and between the blocks. With light pressure, tint some of the larger areas irregularly to indicate crumbling.

STEP FOUR Use sharp sienna brown to add some irregular color areas to the frontmost surfaces. Finish by using very sharp sepia with heavy pressure to further define some of the darkest of the dark cracks, and light pressure to further darken some of the shadows and a few block surfaces.

Smooth Rock

STEP ONE Smooth rock is easy to draw; although it's smooth, it's still rock, with uneven tones and shapes. The important thing is to create overall soft areas of color before adding the cracks and edges. Use sharp putty beige with light pressure for an even base color, applying slightly more pressure to suggest future forms. Unevenness is fine, as long as the individual strokes aren't obvious. In very strong sunlight, the deepest shadows appear totally black; fill these areas with black and spray a light layer of workable fixative to prevent it from polluting the light areas as you continue.

STEP TWO Use French gray 50% and light pressure to develop the rock forms and edges. Some unevenness is good; it helps suggest the imperfections of the rock surface.

STEP THREE Now that the basic soft imperfections of the surface are in place, use a very sharp sepia with varying pressure to draw the cracks. Use heavier pressure where the cracks are sharpest and darkest and lighter pressure where the edges are softer. You may need to sharpen your pencils more than once to ensure these lines are crisp. Use sepia with light pressure to darken areas that are lit more obliquely.

STEP FOUR To warm the rocks where they undulate slightly and where they reflect light off one other, add hints of sandbar brown with light pressure. Use French gray 50% again to add back a bit of reflected light in the lower boulder's shadowed area. Finish by sharpening the silhouette edge and cracks with black, if necessary.

89 River Pebbles

STEP ONE River pebbles come in a variety of shapes, sizes, and colors. What they all have in common are very smooth surfaces and rounded forms. Start with a light outline. The shapes don't need to be exactly like your reference.

STEP TWO Block in the base color for each pebble with light pressure. For this example, use canary yellow, seashell pink, nectar, blue slate, warm gray 20%, and black cherry.

STEP THREE A second layer of color on each pebble will enrich the colors. On the lightest pebbles, add a light layer of cream to blend. Add yellow ochre to the yellowish pebbles, carmine red to the reddish pebbles, slate gray to the bluish pebbles, warm gray 70% to the grayish pebbles, and black grape to the purplish pebbles. Use sienna brown with light pressure to round the forms, and with heavy pressure to define the shadows.

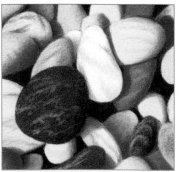

STEP FOUR Fill the gaps between the pebbles to keep the edges crisp, using black with heavy pressure. Further deepen each cast shadow with warm gray 70% next to the overlapping edge. You might need to add a bit of black to the purplish pebbles to darken the edges. Use a colorless blender with heavy pressure to smoothly blend the colors. Be sure to clean the point before moving from one color area to another to avoid streaks. Finish with a few touches of white and warm gray 70% to suggest striations in the colors.

Sand

STEP ONE The grains of ordinary sand are an array of colors: white, tan, red, brown, and even black. It's easy to portray sand's coarseness without drawing every grain. Start with a layer of light peach and a layer of French gray 30%, applied with a dull point. Don't worry about unevenness. Moisten a paintbrush or cotton swab with odorless mineral spirits, and apply it overall to dissolve the wax. This will ensure that subsequent darker colors won't blend into the light colors; they will stay rough.

STEP TWO With very light pressure, hold the pencils on their sides and apply thin layers of light umber, Tuscan red, and sandbar brown.

STEP THREE Use dull light umber and light pressure to indicate some undulations in the sand. Note that the undulations have no sharp edges. Sand closer in the foreground appears coarser. To indicate this, use the pencil on its side in the lower region. Sand in the background appears finer. To indicate this, use the pencil point with very light pressure to fill in pigment gaps in the upper region.

STEP FOUR Add more small, subtle undulations in the same manner as you did in step three. Finish with hints of dark umber and Tuscan red to increase the contrast of the larger undulations, again using the sides of the pencils in the lower region and the points in the upper region.

91 Seashell

STEP ONE The pearly iridescence inside a seashell may look daunting, but it's easy to create by overlapping light colors. Start with a light graphite outline. The outline shown here is darker for demonstration; use poster putty to immediately dab away as much graphite as you can and still see the outline. This will prevent the graphite from polluting the light colors. Go over the whole shell with white to create a waxy base layer, which will allow for a smooth blend of colors.

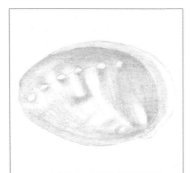

STEP TWO Lightly create areas of color with very sharp light cerulean blue, light green, and pink rose, allowing some of them to overlap in a few places. Reserve the highlights, which are mostly in the center.

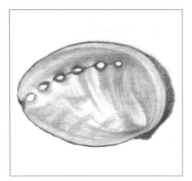

STEP THREE Use a sharp grayed lavender with light-to-medium pressure to begin blending the previous step's layers together. Add a little more of each color to increase their intensity, and make some curved streaks toward the innermost depression at the bottom right. Continue to reserve the highlights. Use sharp artichoke and sandbar brown to define the holes and the rim of the shell.

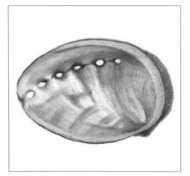

STEP FOUR Very sharp slate gray with medium pressure is perfect for increasing the contrast of the interior ripples and suggesting more depth around the inside of the rim, as well as adding a bit of color to the outside of the shell. Use very sharp lavender and light strokes to punch up some of the areas where you used pink rose earlier. Use very sharp sandbar brown and dark brown with very light pressure to achieve final crispness in the holes and the rim, as well more depth in the darkest inner shadows. Finish by smoothing the interior with a colorless blender.

Running River

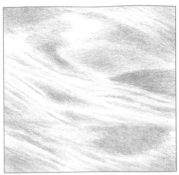

STEP ONE Running water is tricky, because there are so many flowing lines of colors that it's easy to get lost. Rocks with water flowing over them have blurred edges, and an outline would only confuse. Cover the entire area with a layer of white to provide a waxy layer for smooth blending later. Then start with just two sharp colored pencils, blue lake and cool gray 10%, and light pressure to plan the rocks around which the water flows and the most colorful areas of the water.

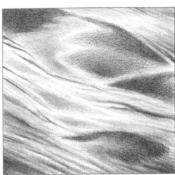

STEP TWO Give more form to the rocks with sharp cool gray 30%, and indicate some darker ripples in the water with this pencil and sharp slate gray. Enhance the bluest areas with more blue lake. Notice that these blue areas are always surrounded by highlights; reserve these highlights.

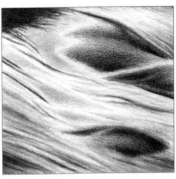

STEP THREE Enhance the rocks further with sharp cool gray 70% and medium pressure. Then add streaks (ripples) in the water by tapering your pressure from light to medium to light again.

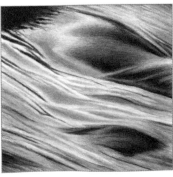

STEP FOUR Continue developing the blue areas of water with very sharp blue lake and slate gray, adding streaks of all the colors throughout the water. Use sharp cool gray 90% with medium pressure to give final contrast to the rocks and the darkest streaks in the water. Use sharp white to smooth the boundaries between the blues and highlights. Finish with a colorless blender and heavy pressure to smooth the rocks and eliminate speckles throughout.

93 Still Lake

STEP ONE Still water can seem daunting, because the reflections are vertical while the ripples are horizontal, and the shapes are indistinct. The key is to work on the vertical and horizontal aspects separately. Begin with a medium layer of the base colors: chartreuse, kelp green, and sky blue light. Keep all your strokes vertical. Overlap the chartreuse and kelp green somewhat.

STEP TWO Add a second medium layer of colors over the first: artichoke, marine green, and cool gray 20%, respectively. Again, keep all strokes vertical. Allow the coverage to be uneven.

STEP THREE Now that there are two layers of pigment, moisten a paintbrush or cotton swab with odorless mineral spirits and apply it overall to dissolve the wax away and produce a more even color throughout. Most speckles of paper showing through will disappear, but it's good for some to remain, suggesting sunlight on distant leaves. After the mineral spirits have completely evaporated, enhance the darkest areas with espresso and the golden trees with areas of beige sienna. Again, keep all strokes vertical and coverage uneven.

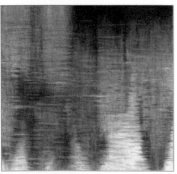

STEP FOUR Lightly spray a layer of workable fixative to create a barrier so you can make light marks atop the dark areas without them blending. When the fixative is dry, use very sharp pencils and horizontal strokes to break up the edges of the tree shapes and add ripples. Use white, cool gray 20%, cool gray 30%, sand, marine green, and espresso. Stroke light colors into dark areas, and dark colors into light areas. To suggest distance, make the background ripples longer, thinner, and farther apart. Finish by touching up any areas that need more color, and use a colorless blender to smooth.

Rippled Lake

STEP ONE Rippling, waving water may seem intimidating due to the multitude of details, but it's just a matter of starting with major features and working toward progressively smaller details. Begin with a layer of white to provide a waxy base for smooth blending, followed by the base color, sky blue light, applied with a sharp point and light pressure.

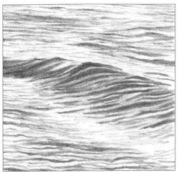

STEP TWO Note that all ripples are wavy, and ensure that all your strokes taper to points. Identify the most prominent ripples in the wave, and draw them with very sharp Mediterranean blue and medium pressure. Once the wave is placed, do the same for the most prominent foreground ripples. Use very sharp peacock blue to draw the most prominent background ripples; they are a different color because they are farther away. Now that all the most prominent ripples are located, draw some of the lesser ripples.

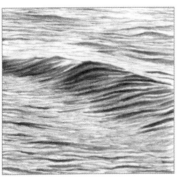

STEP THREE Use very sharp indigo blue with medium pressure to enhance the contrast on the most prominent ripples throughout. Use very sharp peacock blue between some of the major ripples in the wave to develop its form. Use both pencils with very light pressure to suggest even smaller ripples within ripples in the foreground and in the leading trough of the wave.

STEP FOUR Continue developing ripples as in the previous step, and add more with a very sharp Mediterranean blue. You may want to go back over some previous ripples with more pressure or widen them. Your ripples don't have to exactly match your reference; they only need to look like ripples, so don't try to draw every detail.

Bubbles

STEP ONE Bubbles look different depending on whether they are in air, on a surface, or under water. In nature, most bubbles you see are on a surface, in a cluster held together by surface tension. They are relatively flat, and they aren't perfect circles because they tug on each other. Start with a basic outline of the perimeter of the bubbly area and the largest bubbles.

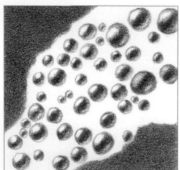

STEP TWO With sharp sepia and medium pressure, fill the background. Note that every bubble has a bright highlight nearest the light source and a soft reflection of that highlight on its opposite interior wall. It's transparent, so the color between the highlights is the color of the surface it is on, and it's darkest halfway between the highlights. In this example, the light source is at the upper left. With very sharp sepia and light pressure, form the largest bubbles per these rules.

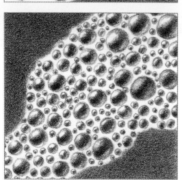

STEP THREE Continue drawing smaller bubbles of various sizes around the largest bubbles. Don't try to draw every bubble in your reference—many of them are microscopic and are simply what compose the white areas between those you can see.

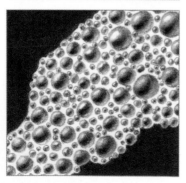

STEP FOUR Bubbles like this have no color of their own; they transmit, or reflect, the colors around them. In this example, the surface is the flat sepia you already drew. With very sharp eggshell, add a margin along the highlight edge to suggest that something of that color out of view is being reflected. With very sharp sky blue light, add a margin along the soft interior highlight to suggest the sky being reflected. Since each bubble is unique, variations in these colors and their locations is normal. Finish by using sepia with heavy pressure to fully darken the background.

Fire

STEP ONE Fire has a challenging structure to render—curls and swirls that change from moment to moment. Fortunately, the number of colors required is small. Flames range from white (or sometimes blue) where they're hottest to red where they're coolest. We can't outline the flames, because the outlines would remain visible, so start with a medium base layer of canary yellow under the entire extent of the flames. The shapes don't need to be exact, because we will refine them as we go.

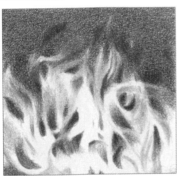

STEP TWO Use sharp crimson lake with medium pressure to fill the background. Use sharp orange and permanent red with light pressure to define the major shapes and swirls within the flames.

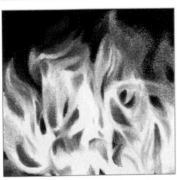

STEP THREE Use black with heavy pressure as a second background layer. Identify the darkest/reddest flames, particularly at the top, and create them with sharp crimson lake and heavy pressure.

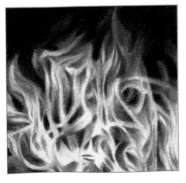

STEP FOUR Continue creating smaller and smaller shapes and swirls within the flames with sharp canary yellow, Spanish orange, orange, permanent red, and crimson lake and medium-to-heavy pressure. If needed, finish with a colorless blender to achieve smooth blends.

97 Ocean

STEP ONE Ocean waves and foam are very complex, but surprisingly easy to draw with blues and greens, reserving the foam and sea spray. Start with a medium layer of Caribbean sea in the distance and in the darkest areas under the curl of the breaking wave. With sharp sky blue light and medium pressure, create the middle ground, and use sharp gray green light to create the curl of the wave, reserving the crashing foam.

STEP TWO With very sharp marine green, lightly add ripple lines in the distance and middle ground, and use medium pressure to deepen the areas under the curl of the breaking wave. Add a few touches on the back of the wave.

STEP THREE Use sharp muted turquoise and slate gray to add more ripples in the distance and middle ground, deepen the area under the curl of the wave, give more form to the curl, and define the foamy areas on the water surface. Also, use these pencils to indicate parts of the spray that are in shadow.

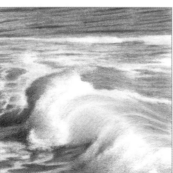

STEP FOUR With very sharp cool gray 90%, create the darkest shadows of the wave and darken a few of the distant ripples. Note that much of the foam on the water's surface is not bright white, because it is thin. Use very sharp cool gray 10% and medium pressure to reduce the brightness of some of those areas. Use this same pencil to also add softness and form to the spray on the curl. Finish with a colorless blender to smooth.

Clouds

STEP ONE Clouds often contain many colors, but for this example you only need blues and gray. Begin with a light layer of cloud blue light to define the sky behind the cloud and some of the shapes within it.

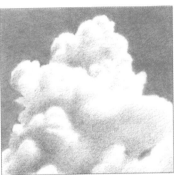

STEP TWO Add a second layer to the sky with sharp blue lake and medium pressure. Clouds have very irregular outlines, so your drawing doesn't have to look exactly like your reference. Give some form to the shapes in the cloud with very sharp periwinkle and very light pressure.

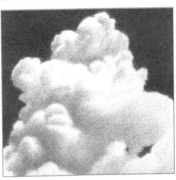

STEP THREE Add a third layer to the sky with sharp Copenhagen blue and heavy pressure. The three layers together produce a bright, smooth blue like a summer sky. Keep the cloud border very crisp. Continue adding smaller forms in the clouds with very sharp periwinkle and very light pressure; add more periwinkle in the darkest areas.

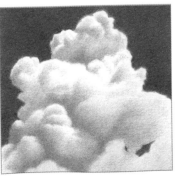

STEP FOUR Deepen the recesses in the cloud forms with more periwinkle. Then use very sharp cool gray 10% with very light pressure to add the lightest puffy shapes, reserving bare paper for the brightest highlights. To finish, use cool gray 10% with light pressure to smooth the periwinkle throughout the clouds, and, if needed, sharpen the cloud border with Copenhagen blue.

99 Raindrops on Water

STEP ONE The hardest aspect of rendering raindrops on water is drawing the rings they create with clean, sharp lines. Begin with a light layer of white to provide a waxy base for a smooth blend of the darker colors to come, and a light, even layer of cloud blue light applied in horizontal strokes.

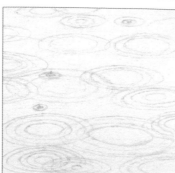

STEP TWO Note that the longer it has been since a droplet hit the water, the wider the ring and the shallower and closer together the rings are. Any droplet that has just hit causes a little pyramid with a very small ring around it. With very sharp periwinkle and very light pressure, draw the basic rings and impacts. Don't worry if a line is a little rough—you will have an opportunity to smooth it in the next step.

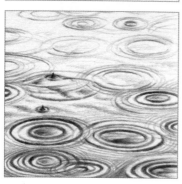

STEP THREE With very sharp indigo blue, draw the tiny impact pyramids with heavy pressure, enhance some of the rings with medium pressure, add more rings between other rings with light pressure, and add more extensive peripheral rings with very light pressure. Add a few ripples in the undisturbed water with light pressure.

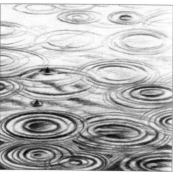

STEP FOUR Use very sharp black to enhance the fattest rings in the foreground, using the same pressure that you used for those same rings in the previous step. Finish with light touches of black to enhance contrast in the foreground.

120

Raindrops on a Window

STEP ONE The keys to successfully rendering raindrops on a window are creating the blurry background and noticing that what makes the droplets visible is that they invert the scene behind them. Begin by outlining the droplets with cool gray 10% and using it as a medium base layer for the background blur to promote a smooth blend in the colors to follow.

STEP TWO In this example, the background consists of an overcast sky, shrubs, and wet soil. With sharp marine green, sandbar brown, and light umber, apply light-to-medium pressure to fade the colors into each other around the lower half of droplets. Use sharp sepia with light pressure to darken the area between the green and brown. Use cool gray 20% with light pressure to darken some of the overcast sky.

STEP THREE Begin forming the outlines and reflections on the upper half of droplets with cool gray 30%, and on the lower half with marine green, using medium pressure. Reserve bare paper for the brightest areas of the droplets.

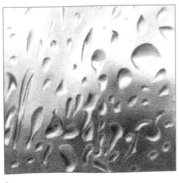

STEP FOUR Define the upper half of the droplets with sharp marine green over the gray, and the lower half with sharp light umber over the green, using light pressure. Smooth the transitions to white with very sharp cool Gray 10% and medium pressure. Define the dark edges with very sharp sepia and light pressure. To finish, sharpen the borders of all droplets as needed with the color of the background behind them.

101 Fall Foliage

STEP ONE Autumn leaves are easy to draw, because they are naturally uneven in color. Start with a light outline, and apply a light layer of cream over all the leaves.

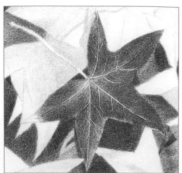

STEP TWO Use a stylus or other sharp tool with light-to-medium pressure to impress lines for the red leaf's veins. You should do this after the initial cream layer to ensure that the veins have color. Then fill the leaf with sharp carmine red and medium pressure to make the veins appear, stroking in the same direction as the leaf "fingers." Fill the background (dying grass) with a medium layer of green ochre. Use sharp sand and light pressure to block in the shadows of the dry leaves and give them some form.

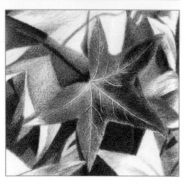

STEP THREE Add the discolorations on the red leaf with sharp black raspberry and medium pressure. Use it with light pressure to darken the shadows cast by leaves onto other leaves, and with heavy pressure to darken the shadows cast by leaves onto the grass. Add the leaf stem with sharp carmine red, and then apply sharp black raspberry on the shadowed part of the stem.

STEP FOUR To give the red leaf its full brightness, add crimson red with heavy pressure. The edges and base of the red leaf are lighter, so use less pressure in these places. Add more black raspberry to the discolorations. Press the tip of very sharp carmine red into the impressed lines to reduce the contrast of the veins as needed. Blend the dry leaf colors and shadows with sand and heavy pressure. Create the dry leaf veins with very sharp black raspberry and very light pressure. Finish by using very sharp black raspberry with light-to-medium pressure to clean up the edges.

ARTIST'S GALLERY

Anangueo Kitchen, by Denise J. Howard, 22" x 12", colored pencil on paper

AGED WOOD (#60), **CLAY POTTERY** (#50), **PORCELAIN** (#44), **POLISHED SILVER** (#46)

Monarch #2, by Denise J. Howard, 7" x 5", colored pencil on paper

BUTTERFLY WING (#24), **MOSS** (#84), **ROUGH TREE BARK** (#78), **PINE TREE NEEDLES** (#79)

Colossal Companions, by Denise J. Howard, 7" x 9", colored pencil on paper

CLOUDS (#98), **SMOOTH ROCK** (#88), **ROUGH TREE BARK** (#78)

Eugene's Time to Rest, by Denise J. Howard, 8" x 10", colored pencil on paper

DENIM (#30), **COTTON** (#31), **GRASS FIELD** (#85), **LEATHER** (#35), **WAVY HAIR** (#5), **AGED SKIN** (#2), **NOSE** (#8), **LIPS** (#9), **POLISHED SILVER** (#46)

Spanish Spices, by Denise J. Howard, 20" x 15", colored pencil on paper

WOVEN BASKET (#39), **SMOOTH ROCK** (#88), **COTTON** (#31)

Tree of Stories, by Denise J. Howard, 20" x 15", colored pencil on paper

SMOOTH TREE BARK (#77), **ROUGH TREE BARK** (#78), **GRASS FIELD** (#85), **MOSS** (#84)

About the Artist

DENISE J. HOWARD grew up on a farm in rural Missouri surrounded by animals and nature. As soon as she could hold a pencil she started drawing everything, and her world revolved around her art until she finished college. She earned a BA in art and a BS in math/computer science concurrently from Truman State University, and later an MS in computer science from Ohio State University, focused on computer graphics. Denise worked for several Silicon Valley companies, was one of the developers of iPhoto® at Apple, and earned movie credits on *Antz* and *Shrek* at PDI™/DreamWorks. Software engineering left little time or energy for creating art for more than 25 years.

Finally, the urge to return to art became too strong to ignore, so Denise began committing the time to pursue it as a second career and quickly began receiving local, national, and international recognition for her realist colored pencil and graphite work. She is a signature member of the Colored Pencil Society of America (CPSA) and the UK Colored Pencil Society (UKCPS) and has Master Pencil Artist Status (MPAS) with the Pencil Art Society (PAS).

Denise lives in Santa Clara, California, with her husband and a garden full of native plants and hummingbirds. To learn more, visit www.denisejhowardart.com.